LEOPARDS IN THE CELLAR

LEOPARDS IN THE CELLAR

THE MEMOIRS OF A CARTOONIST

JOHN TICKNER

THE
SPORTSMAN'S
PRESS
LONDON

Published by The Sportsman's Press 1991
© John Tickner 1991

To Barbara, my wife, for
all her help and understanding

A catalogue record for this book is available
from the British Library

ISBN 0–948253–56–4

Printed in Great Britain by
The Bath Press Ltd

Contents

Acknowledgments

The author and publisher wish to thank everyone who has helped with this book. Particular acknowledgments are due to the editors and publishers of productions in which illustrations used in this book first appeared. These include *Horse and Hound*, the *Shooting Times*, Putnam, Mr Richard Grant-Rennick (The Standfast Press), Illustrated Newspapers and various service magazines that appeared during the Second World War. Thanks are also due to Susan Coley, editor of this book, for her considerable help and encouragement.

Foreword by Michael Clayton

LOOKING for John Tickner's cartoon of the week has become a ritual for many thousands of *Horse and Hound* readers.

Clearly, they regard him as a friend as well as an entertainer. His humour is based on a deep knowledge and affection for the way of life of those closely involved with horse and hound in the setting of the British countryside.

His autobiography will surely be welcomed by his many admirers. They will find that John's art is enhanced by a wide experience of life at home and abroad.

His exciting wartime as an intelligence officer in East Africa, India and Burma, is conveyed pictorially as well as in his modest account of his own endeavours.

A deep love of English rural life shines through his memoirs. It was a happy day when we arranged that John's cartoons should be a weekly feature in *Horse and Hound*.

His memoirs will produce further entertainment, enlightenment and even surprises for those who relish his sense of fun and his witty draughtsmanship.

Introduction

As a young reporter on a local newspaper I had my dreams. All who entered the profession as a junior or 'cub' reporter, as they were called, must have dreamed as they walked wearily homewards along the cold wet suburban pavements on a dark winter night after boring hours in a dreary town council meeting (in the 1930s junior reporters could not afford cars), or perhaps standing on a hot summer afternoon at a church garden fete taking down the names of stall-holders, of the possibility of a romantic, adventurous future in exotic places. Many achieved this, others, thanks to the 1939–45 war, had it thrust upon them, and many others have reached high places in likely and most unlikely careers and doubtless will continue to do so.

My fantasies were concerned with rather wild adventures, mostly abroad, but never did I imagine spending an afternoon locked in a cellar trying to sketch two loose leopards, walking into a kitchen and meeting a disgruntled hyena on its way out, sleeping for weeks with a young leopard on my bed, seeing lions at close quarters and being blamed for 'causing embarrassment by being present in the middle of a battle'. Yet all these things happened and much more.

I did not rise to particularly high places, literary or otherwise. It was the inclination to draw at the slightest opportunity that ruled my life and this, coupled with what some people have regarded as a warped sense of humour, has got me through some difficult times as well as made some very happy times even happier.

Quite late in life, after I had retired from a full career in journalism (with the exception of the war years) from junior reporter to editor, I became cartoonist to *Horse and Hound* – a publication I used to save up to buy when I was a schoolboy. Today I do my drawings in a small house in Herefordshire with a rear view across fields containing other

people's livestock in summer, to distant woods and hills. It is the kind of existence I dreamed about as a reporter on a local newspaper and as a soldier in the Burma jungle. Anyone can do it with a fair amount of persistence, hard work and luck. But, above all, you need the encouragement and backing of someone who has faith in you and is prepared to put up with a lot to see the success of your efforts.

An ideal existence, the public's idea of a rural author.

The Backs of Envelopes

I started drawing at an early age. My half-sister, Mollie, a few years my senior, tells me that when I was five years old I was always drawing things on the backs of old envelopes and other bits of waste paper, which were then pinned up in the family 'loo'. I understand that some of my more recent efforts are displayed in similar 'smallest rooms' in some quite large and interesting houses, which is a gratifying thought.

I was born in 1913 at Stoke Green, Warwickshire, which, in those days, was a village on the outskirts of Coventry but is now an industrial part of the city. The house was one of a number surrounding a genuine village green of the traditional kind, complete with duck-pond and also a pound into which stray cattle and horses were put until claimed. There was a cricket pitch on which matches were played regularly and a few carthorses and cows grazed peacefully on the green in the summer. I remember in particular one cow, always referred to as 'the Alderney', and a large carthorse we children knew as 'Kate' who wandered vaguely about the area and sometimes into our front garden, if anyone left the gate open.

Kate had a solemn face and a long Roman nose and was either named after a maid we had at the time or vice versa; I can't remember which, but I do recall that they closely resembled each other in appearance and movement and that we regarded both with affection.

My father was a well-known architect in Coventry and had high hopes that one day I would follow in his footsteps. My brother Michael, two years my junior, and I were children of a second marriage, my father's first wife having died when her fourth daughter, Mollie, was born and so we had four half-sisters with whom we got on very well although it must be admitted that two of them were away from home, nursing most of the time, while a third worked in father's office. Mollie, the

My mother, Frances Drake,
photographed in nurse's uniform before
her marriage

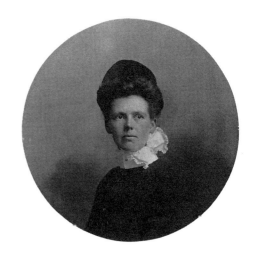

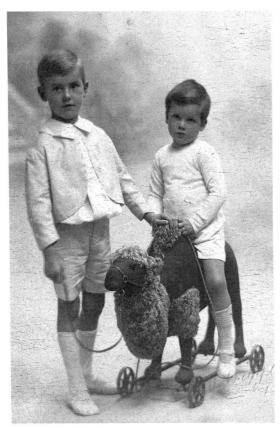

(*above*) With my brother Michael
(riding the camel) about 1918.
(*right*) Michael pretending to sit on a
different form of transport; in the
garden at Stoke Green, Coventry
about 1922.

youngest and the only survivor of the half-sisters today, was eventually Matron of Paignton Hospital. Mother had been a highly qualified nurse and was the midwife to Mollie's mother when she was born.

Mother had kept in touch with Thomas Tickner and his family after she had left Moorlands, as our house was called, when her nursing duties were over. Some time later Thomas Tickner, architect, and Frances Drake, nurse, were married. Mother said that her maiden name was sometimes an embarrassment but she seldom met Spaniards anyway. Only one of my aunts claimed the famous Francis as an ancestor. The rest of us didn't bother; in fact I lost a tie-pin the design of which was apparently based on the Drake arms, without being particularly upset, although the aforementioned aunt was rather annoyed.

A happy family life ensued enhanced, no doubt, by my arrival in 1913 and by Michael's assistance to balance the genders a little, two years later. We boys were luckier than many modern children in that we were often able to keep away from boring grown-ups. We had our own nursery and an extremely kind nanny who was always amusing, often unintentionally; indeed I'm sure she helped to develop my latent sense of humour.

She used to push us out along the Warwickshire lanes in a huge perambulator which seemed to me to resemble a double decker bus. There was room for Michael inside and for me in an outside attachment in which I could sit and survey the world. One day we had a head-on collision with a pram pushed by the nanny employed by the family of a solicitor who also lived at Stoke Green. Both nannies were short, short-tempered and Irish. There was a great deal of noise, the sound of nannies loudly criticising each other's pram-driving mingling with the sound of the tangling of the vehicles.

Later there was a Miss Stone, known to us affectionately as 'Boney' whose duties seemed to involve being a kind of Mother's help and a sort of older child's nanny without uniform. She was really a child's companion, took us for walks and, indeed, always seemed to be present, even accompanying the family on holidays. We were extremely fond of her and were very sad when she had to leave after father's death.

The only pet we had at that period was a fox terrier who lived to a good age and once distinguished himself by crossing from one side of busy Coventry city to the other, having only done so by taxi previously,

My parents, Thomas and
Frances Tickner, about
1920.

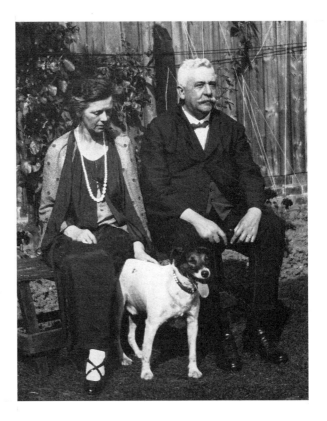

in a determined effort to return to the old home when we had moved.

We saw our parents often, Mother visiting the nursery regularly.
Father we saw in the evenings when he came home from the office,
and at weekends. There was the occasion when he consulted me profes-
sionally; I must have been eight or nine at the time. He asked my advice
about how to draw horses having noticed that horses were my chief
subjects. His architectural drawings were superb but he could not depict
creatures. He was submitting designs for a competition open to local
architects for the Coventry War Memorial and he proposed to send,
as one of his contributions, a design incorporating the figure of St George
on horseback. I duly produced a sketch for him. It puzzled him that
I always drew horses starting at the rear end. I had not yet learned
that it was unwise to approach a horse from that direction. I suppose
my juvenile sketch was passed on to a competent artist to translate.
The design did not win; could it have been that the adjudicators con-

sidered that a horse with a cynical smile on its face would not be appropriate?

The competition was won by another design of my Father's, without a horse. The entries had to be submitted anonymously and Father died suddenly before the awards were known. The work was carried out by the firm of architects who took over his business and the memorial still stands in the park on the Kenilworth road leading out of Coventry.

After father's death, one great problem for mother was the matter of our education. Father had intended to send us to a public school but that was obviously now out of the question. Mother had moved from the Coventry area, with my brother and myself, to a small house in the London suburb of Ealing where her four single sisters lived. She managed to send us to a small private school, now long since defunct, run by a little man who ran excitedly about like a demented mouse with a wispy moustache. The education dispensed was not of a high standard but I am convinced that it was at that curious establishment that I first had my taste for cartooning. The frenetic mouse-like head-master-proprietor was such an obvious subject for a strip cartoon that I could not resist the temptation. He consequently appeared on the backs of countless envelopes.

The first fifteen years or so of my life might well be described as my Back-of-Envelope Period. The backs of old envelopes were and still are, so much cheaper and handier than quality art paper and for rough sketches they are ideal. My very first public, the other nasty little boys of the sort who instinctively regard schoolmasters as the right kind of animal to bait, laughed heartily when shown my efforts in secrecy during 'breaks'. This did my ego no end of good and undoubtedly was the start of the thousands of cartoons I have produced during the last seventy years or so.

The education situation was soon relieved. Father had been a free-mason for many years and so had our maternal grandfather. Although freemasonry has never appealed to Michael or myself, for various reasons, it proved to be a godsend to mother at this moment. We were both accepted for the Royal Masonic School for Boys at Bushey, Hertfordshire, and went there as boarders. The school does not exist now but in the 1920s was run entirely on public school lines, down to its own

cadet corps, which was associated with the London Rifle Brigade. It was also on the Headmasters' Conference, along with the best of public schools, to the undoubted delight of the more snobby element of our relatives. To us boys it might just as well have been Borstal. I'm sure it was a splendid establishment but we were determined not to like it and we didn't.

I have always disliked being among a crowd of people – four is about enough – and the crowd at the Masonic, even in one House, was too much. To be among so many other disgruntled little boys of an astonishingly wide variety of origins, was a disconcerting experience, bad enough in anticipation and a lot worse in reality. I don't remember much of the early days apart from a gloomy, hopeless, feeling of homesickness. This, once one had settled down, as much as one ever did, was replaced largely by utter boredom. I always had a low boring-point.

All was well for new boys who liked sport and were good at it. I didn't and I wasn't. Being a loner by nature I disliked having to be part of a team, but it was made clear to me that it was unsporting to play cricket or football by oneself so I did not like cricket or football from that time onwards. I still don't. Perhaps I should correct that a little. I learned to enjoy Rugby football because I discovered that when playing in the scrums, one could bring people like school bullies, always hefty, ape-like creatures, crashing down on their faces. The heavier they were and the faster they were running, the swifter and more spectacularly they fell. Of course one soon learned to do the job properly, for if one grasped the ape loosely or sloppily round the waist or particularly round the knees, one was liable to make a mess of the whole thing and get a ferocious kick in the jaw. Incidentally it seems to me from what little Rugby football I see on television, that the art of clean, smooth, low tackling has almost gone today; one sees instead much clumsy, untidy cuddling. That does not apply to the top people in the game of course, he wrote hurriedly. I did enjoy another sport, long distance running, because one was alone and could think one's own thoughts.

Continuing to use drawing as my chief means of consolation and best method of escape from the confining world of school, I drew on every possible occasion and still mostly on the backs of old envelopes. I even took to illustrating, in the margins, some of my essays (I enjoyed writing essays as much as I loathed maths and science – fortunately computers

had not been invented or I'm sure we should have loathed each other) but although some masters were quite nice about it at first, it was eventually discouraged as not really the right thing to do. It was several years before I persuaded anyone that not only was it right to illustrate what one wrote but also quite reasonable to expect to be paid for it.

It was in the early 1920s that I met my first world-wide celebrity. This was Field Marshal, later Earl, Douglas Haig. However justified or not the criticisms of his wartime leadership may have been, he was a romantic hero to a schoolboy soaked in patriotism as most of us were.

Haig was going to Coventry to unveil the war memorial in Kenilworth Park, designed by my father just before he died. Mother obtained permission from the school authorities to take me along to the ceremony. I waited on the platform at Watford station for the Coventry train from London out of which my mother was half hanging to indicate her map reference. I scrambled nervously aboard – I was always a nervous and extremely shy child and was very self-conscious about doing things in public such as being the only person to board a train, or, indeed, some years later, the only person being shot at by a hidden machine gunner.

I was overcome with disbelief when I saw the impressive figure on the stage at the unveiling ceremony. Haig was an extremely handsome man with his classic features, his upright, soldierly figure and most important to a small boy, his smart cavalry uniform with perfectly cut breeches and jingling spurs. The famous field marshal looked just what I hoped to look one day. I wished desperately for a chance to ask the great man's advice as to how to do it.

'And what are you going to be when you grow up?' asked this godlike figure as he bent down, all benign and jingling, to talk to me.

'Oh, Sir, a soldier, Sir,' I said as soon as I could speak, half hoping for a swift commission in the Bengal Lancers or some other such romantic unit.

'Don't' he said. 'Don't ever be a soldier!' I think he meant it sincerely, with world peace in mind but I have often wondered whether he was judging by appearances.

The first indications of my future joint career of writing combined with drawing occurred at school. I was never a caricaturist as most people seem to think every cartoonist is automatically. A good cartoonist

is not always so, but many are both and nearly all cartoonists can get a reasonable likeness. However, I had an urge to get down on paper a drawing of every master on the staff, from the headmaster to the ex-army sergeant-major P.E. instructor and the man who taught woodwork.

This I did in a small sketch book. It was soon confiscated from a borrower who was flatteringly more interested in it than in the Shakespeare work set for that particular lesson. My early efforts thus disappeared from public view for some time and I gathered they were passed round in the Masters' Common Room. They didn't do me any harm because, although by no means brilliant, they seemed to have caused the 'victims' some amusement.

At about the same time I had an opportunity to write my first 'funny'. I was caught, with others, fooling about and making a noise in the dormitory just after 'lights out'; the punishment was an order to write an essay entitled 'Decorum in the Dormitory'. I decided to treat the subject lightly and to my amazement had my essay published in the school magazine that year. And so my literary and illustrating efforts, to become so important to me later in life, first saw the light of day at school over sixty years ago.

One great pleasure throughout my time at the Masonic was the Art Club. This was one of the voluntary activities in which one could take part after school. In the summer we spent many a happy hour sitting on small stools sketching the large trees of which there were many in the neighbourhood and the farms and barns. In the winter we drew still life or, what I particularly enjoyed, subjects conjured up in our imagination.

The Art Master was a quiet, gentle soul whose advice and encouragement was largely responsible for my continued efforts later in life. After I left school I discovered that this man, A. R. Brown, was a distinguished water-colourist; I shall always be indebted to him for his individual instruction and confidence in my future career.

On the whole school life was extremely dull, enlivened now and again by lectures from mostly minor notabilities who had climbed mountains, visited places we had never heard of and mostly didn't want to do so, or were experts on some subject which one didn't understand any more after the lecturer had gone than one had before. Sometimes the pictorial slides were entertaining, especially when they came on upside down.

It was also fun when the lecturer was accompanied by something live, such as a hawk, which became utterly bored by flying aimlessly round and round the Great Hall and did something on someone's head, preferably a master's.

There was the day when I enlivened the dull routine myself. It was not a matter of exhibitionism. As I have mentioned, I always preferred to hide my light under a bushel or any kind of undergrowth available, but I have always resented being attacked by some person without justification. For that matter I have never liked being smitten by anyone *with* justification, especially not without smiting them back.

For some reason or other the schoolmasters generally seemed to be extra touchy that week. They were particularly irritable about matters such as talking in class. Our classes moved around the school in the course of the day, visiting various specialists such as maths and science masters, both of whom, incidentally, were always beyond my understanding, and experts on languages (I never saw any point in learning these as, according to the parsons who taught Scripture, our missionaries had taught them all English centuries ago).

It was a French class and the master in charge was half Irish and half French and was inclined to be hot-tempered. Somebody, I never knew who was the criminal, made a derisory and generally unpleasant noise.

'Who did that?' shouted the master in French-Irish. No reply. 'Unless someone owns up I shall punish the whole class!'

We expected some group imposition but, instead, white with rage, the master, starting at the right of the top row, proceeded to box the ears of the first boy and, progressing along from desk to desk, with only muffled cries of protest, eventually reached me. As he swiped, spitting fury, I instinctively leapt to my feet and struck. I couldn't reach above his chest which was just as well, but it was quite a thump. The mass assault ceased and after a brief pause for dignity to be restored, the education of all the horrible little boys went on.

I repeat, I don't know what had upset the staff of the Royal Masonic that day but the incident was almost duplicated later that term. This time the central character was a master for whom I had the greatest respect. For one thing he had won the MC in the recent war, but something had undoubtedly made him extra touchy and he, too, began the

Myself, looking pompous, on Comrade, an Ealing Riding School horse in 1929.
I am, reprehensibly, hatless; we were inclined to be careless about our own
safety in those days.

mass-attack-around-the-desks method. Again I waited until attacked
and, to his astonishment, smote him on the chest. Once again everything
stopped in a silence of amazement. No reference was ever made to the
incidents and nothing similar ever happened again, to my knowledge.
I did discover later that masters were not allowed to hit pupils, the
only official chastisement being carried out by the headmaster, with
due ceremony. Nevertheless, since then my sympathy has very much
been with school staff. Nothing would have induced me to be one of
them, even if I'd had the qualification.

The time for leaving school was approaching and so was the need
to find a profession. I could not afford to go to any sort of art school
and there was no hope of walking into any commercial firm connected
with art without any qualifications. In addition to drawing I had always

been interested in putting thoughts down on paper, in English lessons and essays. 'Well, Tickner,' said my house master, a kindly soul, (there were no such things as career masters in those days) 'what are we going to do with you?' It was a rhetorical question and he saved me the embarrassment of saying that I had not the faintest idea by adding 'You seem to like writing; what about being a journalist?'

'What does a journalist do, Sir?' I asked. He looked a bit nonplussed. 'Oh, I don't really know. I think he starts by joining a newspaper as a reporter and then going about reporting things like weddings and funerals.' How right he was.

It was the custom, on the last day of school, for all boys to collect in Big School (the grand name for the main hall used for lectures, concerts, etc.) immediately after breakfast to wait for their names to be read out according to the times of departure and the destinations of their trains. They were then handed their tickets and sent on their way.

For me and a group of others it was the most exciting day of our school career – the last day of the last term. On my hurried way along the cloisters, heading for the main gates, I met the master who had won the MC. He stopped and I stopped. He held out his hand. 'Goodbye Tickner,' he said with a grin. 'Look after yourself!'

CHAPTER TWO

A Pre-War Journalist

THE discussion with my housemaster bore fruit; he had not tried to glamorize the profession of journalism; on the contrary, he had implied that much of it would be rather dull.

I felt that there must be a romantic side to it. Not all those films, even allowing for Americanisation, could be wrong. I had 'The Street of Adventure' aspect very much in mind when I managed to get an interview with the middle-aged Editor of one of the newspapers based in Ealing, the London suburb where we lived. I was taken on as a probationary reporter, known in those days as a cub reporter, and began work next day. I was about seventeen and my first assignments consisted of attending garden fetes in summer, church bazaars in winter, taking down the names of all the stall-holders – woe betide me if there were any misspellings – and collecting vicars' own notes.

I went to the first few events in the company of a seasoned reporter

who acted as schoolmaster. After a few months of this sort of thing I had lost all romantic illusions and nearly followed my brother into the Merchant Service.

Suddenly I was given one of those plum jobs that must befall all local newspapermen eventually. It was and, I suppose, still is, the custom for the big press agencies and the daily national newspapers to have members of local newspaper staffs acting as their local correspondents and sending them news items which are of national importance. I was alone in the reporters' room one evening when I had a call from a Press agency to tell me that the famous Charlie Chaplin was paying a surprise visit to the Cuckoo School, Hanwell, a neighbouring suburb to Ealing, that night; Charlie had spent his early childhood there.

Our photographer, George Ellis, was still on the premises. We bundled into a taxi and arrived at the school just before Charlie. He was charming and, without the comic little moustache he wore on the screen, a distinguished looking man. He was obviously fond of children and performed the tricks with his bowler hat that he did in his films, to the delight of his juvenile audience.

I cannot pretend that it was a world-shaking interview but the fact that the famous Chaplin who was rarely in England, having made his home in Switzerland, was visiting Britain had made it worthwhile sending the story to Fleet Street. It was my first encounter, as a journalist, with the famous. One soon learned from one's older, cynical colleagues never to be impressed by the famous and next morning in the office I casually referred to my meeting with the film star as if I met him on the bus daily; this offhand manner proved to be justified as no-one in the reporters' room seemed to hear what I had said.

A local reporter often has the opportunity to meet distinguished legal personalities attending law courts in the area. When I was regularly reporting inquests at Hammersmith Coroner's court I encountered Sir Bernard Spilsbury, the pathologist whose name became well-known in connection with notorious murder trials. He was kindly and jovial and used to sit with us at the Press table and tell us stories of the 'have you heard this one?' variety.

I had learned to ride a horse when I was quite young and I was flattered when the proprietor of the stables from which I hired a horse asked me to ride the flashiest looking of his string in the local annual show

'Remember what you said about the grey last year?'
(From *Horse & Hound*)

run by the RSPCA. This was a fair-sized event and although not exactly
of national standard it was important to local riding schools and dealers
that their names should appear among the winners.

The class in which I was entered was for the Best Riding Horse. The
procedure was much the same as that for the Best Hack at the more
important shows and competitions and competitors had to walk, trot
and canter. At some events judges ran their hands over the horse's legs.

I had been warned by the owner that this horse, which I had never
ridden before, 'pulled a bit when excited in company'. As we cantered
round I had the greatest difficulty in trying to look as if I were moving
elegantly along Rotten Row; the horse was pulling like a train. To my
amazement we were awarded third prize.

We had to queue up to be presented with our prizes. The female nota-
bility who was handing over the riding whip, which was my award,
raised it high in the air. The horse, obviously thinking it was about
to be assaulted, went into instant reverse and we retreated to the opposite
side of the ring. It was some time before we could be persuaded to
return, covered with confusion – I was, the horse couldn't have cared
less.

As I came out of the ring the horse's owner hurried to congratulate

me. 'I never thought you'd get a prize,' he said, grinning. 'If the judge had attempted to feel his legs he'd have kicked like a machine gun!'

Throughout this opening phase of my career in journalism I frequently thought about trying to earn a living in some form of art and beginning to do so while I was still young. The trouble was that, for one thing I had no idea what branch to choose and, for another, how to go about it.

I did try a short spell at an art class in the evenings at a local technical college when I was off-duty which was not often. Unfortunately the long-haired young man who, I gathered, was the art instructor (oils, water-colour, charcoal, the lot) seemed more interested in the charms of one beautiful female student than in my wish to learn how to become a cartoonist, which was what I had intended; I continued to remain self-taught and have been ever since although I do not suggest that all would-be students follow my example.

I had, after a year or two in West London, covered all the usual assignments a local newspaperman can expect but with very few of the more exciting stories for which he always hopes.

I became so bored with bazaars, sales of work, church news, town council meetings and inquests – I spent the whole of my nineteenth birthday at an inquest concerned with a motoring crash – that I again seriously considered leaving the profession.

Fortunately a former colleague of about my own age, who now had a job on the staff of a group of newspapers in South Devon, informed me that there was a vacancy for a reporter at the head office in Torquay. This was the late Bob Dobson, eventually home news editor of the *Times* and my brother-in-law, at that time in charge of a Teignmouth paper.

Life in Torquay was much more interesting than it had been in West London; it must have been largely due to the more congenial surroundings. Also it was in Torquay that I had my first political cartoon published. It was carried out on the instructions of the recently appointed middle-aged Editor and depicted a town councillor who was in the habit, during debates, of referring to Torquay's 'streets of gold', falling from Heaven to Hell. To my horror we were informed soon after the cartoon had appeared that morning, that the councillor had died unexpectedly during the night. I still shudder when I think of it.

Mother suddenly decided to come down from London, take a flat in Torquay and live with me. Fond though I was of her, this plan considerably cramped my style although my life had not been particularly wild on a young reporter's salary.

I had, meanwhile, managed to resume contact with horses; having found a local riding stables, I had saved up enough to hire a horse when I was free at weekends. My usual mount was a good-looking and well-bred character called Gay Armour, a relative I understood of the famous racehorse, Gay Crusader. He was, like all thoroughbreds, a beautiful ride when he chose to move like a normal horse. He had, however, the habit of putting in an enormous buck in the middle of a gallop and of suddenly standing on his hind legs when his rider was sitting quietly having a conversation. Yet like so many horses with devious personalities, he would, in the right mood, carry children. So wide was Gay's reputation that I have met people a long way from Devon who knew him well. In those days 'gay' had a normal meaning.

At about this time the first human female who had made any strong impact upon me appeared. My mother had met her mother, apparently a notable person in local circles, and this girl called at the house with a message. She was a striking personality rather than a pretty girl and we soon got to know each other well, very well. She drove a car recklessly and rode a horse boldly.

I had never driven a car (and still haven't) but she would call for me and we would drive out on to Dartmoor for the day. We always

carried a hammer in the car because the way she drove often involved some tricky stone masonry extricating the car from the famous local walls; this particularly happened at sharp corners.

Sometimes we rode together on the moor. On one occasion, below Hay Tor, we were having a bit of a race along a winding, boulder-strewn track when my horse suddenly swerved, throwing me violently and in a most undignified manner; the girl-friend had jokingly flicked the animal's hindquarters with her whip.

The romance finished suddenly. I had volunteered to remain alone in the office on Christmas morning 'in case something important happened'. The doorbell rang. She was standing there, looking very smart and rather Christmassy. 'Happy Christmas!' she said. 'Your mother said you were here and I thought I'd better tell you that it's all over!' She got into her car and drove off.

The Torquay period was by no means all boredom, professionally. As in London, one had the opportunity of meeting some celebrities and among those I interviewed at some of the big hotels were Sir Harry Lauder, Sir Gordon Richards and assorted now-forgotten actors and actresses.

Sir Harry Lauder asked me whether I would like him to sing to me and sitting in a quiet corner of the hotel garden proceeded to do so. When he had finished he said 'You will always remember this. You are the only one-man audience I have ever had!' Years later I met another elderly ex-journalist who had been honoured by having exactly the same experience. I like to think that Sir Harry had a dry sense of humour.

Another interesting assignment was to accompany an ex-wartime (1914-18) air ace in a two-seater biplane while he did aerobatics over the holiday crowds along the sea-front and on the pier. My duty was to bomb speedboats with small bags of flour.

The pilot reminded me, just before we took off, to fasten my seat belt. We flew from Newton Abbot airfield to the coast sufficiently low over the harvest fields to be able to see farm workers pursuing rabbits disturbed by the operations. As soon as we reached the sea we began to perform Immelman turns and we looped the loop and generally flung about the sky so fast and furiously that I was in a daze as I threw out my flour bags, not having the slightest idea of the whereabouts of my targets as the pier, the harbour and the famous rock-walk merged in

a kaleidoscopic blur. On our return to Newton Abbot, the first thing the pilot did was to look into the seat I had occupied in the plane; it was perfectly clean. I got out just in time.

There were, of course, the usual youthful, self-inflicted adventures. On Friday evenings we of the local Press foregathered in a favourite pub and sometimes became rather jovial.

On one such occasion there was, among those present, a photographer of many years experience on Fleet Street publications, who had had countless, almost unbelievable adventures, some of which may have been almost true.

Someone bet this character, whose rugged, amusing face I shall never forget and whose name was Colin, that he would not jump off Torquay pier.

He accepted on condition that someone would do so with him and I, feeling rather swashbuckling, immediately volunteered and my neck was duly placed at risk for one pound. I had made it clear that I could swim, but had never dived in my life.

The performance was arranged for that same evening on which an important meeting of the Torquay Town Council was being held which I first had to attend and report.

There was a large holiday crowd on and around the pier-head where the diving board was. Normally the trapdoor to the board which was placed about 40 feet from the sea level, was locked but it was open on this occasion so that prospective members of the Olympic Team could practise.

I waited, in a great state of nerves, feeling that I was about to jump without a parachute, which indeed I was, until the last of the Olympic experts had climbed back up the ladder and then I hurriedly went on to the board. Watching me among the crowd, who thought I was part of the Olympic team, were the colleagues who had started the wager, and my brother Michael, who was home on leave and was in the know.

Except for the aeroplane adventure I had never been so high from the ground. I was conscious of a sea of faces among the deck chairs, the tops of trees and the glittering sea, far below. I didn't stop to think. I shut my eyes and jumped. I had never been taught to dive so a 'belly-flop' was inevitable but the conditions of the wager permitted me to put newspapers flat inside my bathing costume which I wore under

slacks and a pullover. These I had removed rapidly before climbing the ladder.

I was told afterwards by an old soldier in the crowd that I 'made a splash like a shell' when I dropped into the sea. It seems that I was a long time beneath the water and when I surfaced half dazed, one man had a leg over the pier railing and was about to jump in to the rescue. I managed to haul my way, slowly and semi-conscious and with a black eye, back up the ladder. The boy in charge of the trap-door said, 'You slipped, mate. Do you want to go in again?' I did not.

I spent the pound that night in the Exeter Inn, Torquay, where the wager had been offered and taken. The photographer explained next day that he had been detained on a job in Paignton that evening and had, regrettably, been unable to get away to join me. I didn't blame him.

When Mother was told all about it she was furious; I should have let her know in advance, she said. She would have loved to have watched the fun.

It was about time that I returned to London. Life had continued on much the same lines for some time. I had no particular girl friend, just the usual companion for visits to cinemas that a young man in his late teens had in those days, although a newspaper reporter, whose hours were always irregular, found it difficult to plan any steady romantic campaign with a girl friend.

I encountered the object of what had been my first romance one Saturday morning in the Strand, Torquay, apparently on a shopping expedition. We had published a photograph of her wedding a few weeks earlier. 'Hullo,' she said. 'How are you? I am a respectable married woman now!' We didn't meet again.

I had no reason to stay in Devon and was so anxious to return to London where, I thought, there would be more chance of progression in my profession than in the provinces, that I replied to an advertisement for an editorial assistant on a religious newspaper with a Fleet Street address and was accepted.

I felt rather a fraud because I may have given an impression when applying for the job that I was religious. I was not a barbarian but was not and am not orthodox anything. However, I found the editor of this

rather old-fashioned publication, in its fusty Dickensian building near the Ludgate Circus end of Fleet Street, to be a congenial, worldly character with a sense of humour.

The appointment gave me a foothold in London's journalism once again and I had few regrets at leaving Torquay. I took digs near King's Cross station and walked to the office every day. In addition to the Editor and myself there were two other members of the editorial staff – a young man and a young woman, both with a great sense of humour. He was killed, flying, I learned later, in the early days of the war.

The girl was very interested in horses and we arranged to meet one Saturday and hire two horses from some stables she knew on Epsom Downs. We duly met and rode out on quite respectable looking mounts. I soon had an opportunity to show her my enthusiasm and care for horses. She seemed to be a capable horsewoman and I saw every prospect of it being a pleasant and possibly romantic ride. Unfortunately her horse let us down. It fell down and naturally, as it got up, I hurried to see whether it had hurt itself, running my hands over its legs and generally doing all the right things.

It was soon clear that I should have done some of them to my feminine companion first because she burst into tears. Neither horse nor girl were damaged and many years later, after the war, having seen a review of one of my books, she contacted me and we had a pleasant lunch together.

We found that we were both married by this time and it was a serene and uncomplicated meal.

I was again becoming restless and bored with living in a small room by night and dealing only with journalism of a religious nature by day. It did not seem there would be much chance of any artistic activity but suddenly there was an unexpected opportunity.

I was instructed to attend a meeting at the City Temple which was to be addressed by the famous old politician Lloyd George, then, of course, in retirement. I duly attended and reported his speech which I do not recall as being sensational. I could not, however, resist the opportunity of doing a sketch of the great man from life. This I did on the back of a convenient envelope and somewhat casually, I hoped, and certainly hesitantly, showed it to the Editor next morning. To my surprise he decided to use it; it was the first serious sketch of a famous person I had ever had published.

I met Bob Dobson, my old acquaintance from the early days of journalism, the one who had referred me to the Torquay job from Ealing, again at about this time. He had gone from Torquay to the *Morning Post* and eventually to the *Times* and he told me that there was a vacancy on the *Acton Gazette*, a paper belonging to the group on which he and I had started. I applied and was given the job.

It consisted of the usual routine work of a local newspaperman, assisting an elderly journalist who had been running the paper for years. He knew everyone of any importance in the area and was a tremendous worker. His hours of duty, largely self-imposed, were phenomenal and he thought nothing of covering a lengthy town council meeting which often started early in the evening and continued late at night, going home and translating his notes into reports ready to go straight to the printer next day. He would ask for a reporter from the Ealing office to be sent to assist him if help was desperately needed but often he would cover several engagements in one evening having already attended a number in the afternoon.

He was finding it a little too much and soon after I was sent to assist him, he retired. When I took over I found that I was virtually Editor and acted entirely as such, taking on a pleasant and capable young man as my editorial assistant.

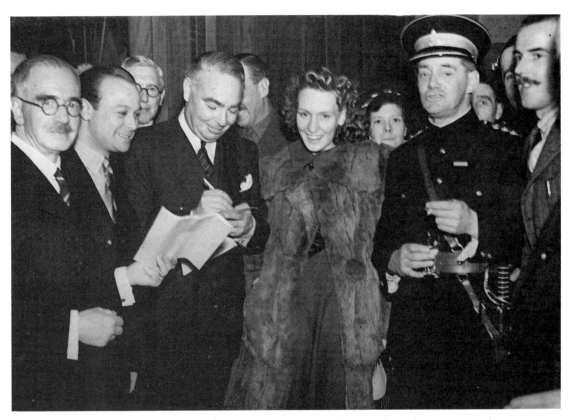

John Tickner, then Editor of the *Acton Gazette*, is standing on the right next to Lord Nuffield. Lord Hore-Belisha is signing an autograph. This picture was taken in about 1938. Lord Nuffield was honorary colonel of a local Territorial unit.

My domestic life changed too. Several years earlier, while still at school, I had met an attractive girl, Doreen Hunt, staying with her parents at Bexhill. She was tall and fair and I found out much later that her mother and mine were very distant relatives. I had kept in touch with her; we wrote flirtatious letters from our respective boarding schools and she came to stay with us at Torquay for a holiday.

Soon after my West London appointment we began to see rather a lot of each other; she lived at Broxbourne, Hertfordshire, and I was still living at my mother's place at Ealing. We married one snowy day a few days before Christmas in 1937 and took a small flat on the Chiswick-Acton border, within walking distance of my office.

There was not much opportunity to commune with horses, dogs or

wildlife in this corner of West London, especially as we were not permitted to have dogs in the flat, but we did manage a few brief encounters with animals.

One such was with a film star who came to live with us for a short time. This was 'Scruffy' a shaggy mongrel, the star of 'Storm in a Teacup', a film produced at that time and revived on television in 1990.

Scruffy was a quiet, gentle dog, not, I thought a good dramatic actor, but with a quality, I gather, that is not general with persons in his profession – obedience and an anxiety to please. We only had to look after him for a short time before he retired and this was easy as Doreen, my wife, had resigned her job as secretary to a London stockbroker when we married and was able to be at home with Scruffy all day.

The actor never barked unless told to do so and so the landlord never found out that he had an illegal tenant.

I also managed to keep contact with horses, hiring from a riding school and riding in Richmond Park at weekends whenever I could afford it.

My wife liked dogs but could not be induced to get close to horses. I did, however, get her brother to learn to ride. He accompanied me to Richmond (this involved a bus ride as neither of us drove a car) and was involved in an incident where I was warned and very nearly summoned for speeding on horseback.

Kenneth was, in my opinion, competent enough to canter. I, riding alongside him, allowed the canter to become a gallop. A race was inevitable in the minds of the hacks who had probably not been allowed to test whether their legs still worked since they qualified for the old horse pension.

A mounted warden, a grey-haired ex-cavalryman I gathered later, cantered cunningly, diagonally, using dead-ground as taught him in the 1914-18 business, if not earlier, and cut us off just as we pulled up at the gate through which I had hoped to ride quietly out unnoticed.

As I sat my horse, facing the ranger in what I considered to be a dignified manner, my hat blew off. I was about to dismount and retrieve it when the ranger barked what I took to be a cavalry order to stay where I was, at the same time requesting the gate-keeper warden to see that I did so.

He then proceeded to tell me how dangerous it was to gallop horses in the park adding 'I've seen you riding here before: you should know better!' He then looked at my brother-in-law and implied that his horse should know better as he had seen it there before. He said I would

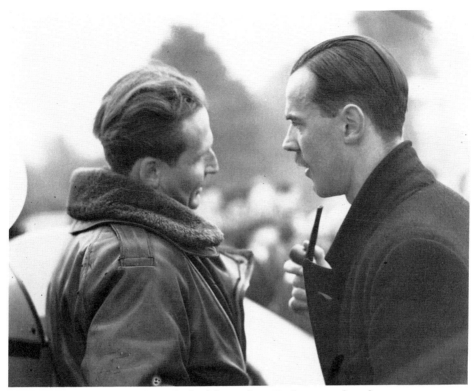

Talking to a Hungarian pilot, who had flown from Budapest and made a
forced landing in Gunnersbury Park on 15 May 1939. He was interviewed
by the authorities, but I did not have any further news of him.

not be prosecuted this time but if he caught me again – ! He didn't.
Of course he was quite right. The fault was mine.

The Chamberlain-Munich business had taken place not long before
and people were breathing sighs of relief, but the barrage balloons went
up that autumn.

Cartoons and Commandos

I had been brought up in what, I suppose, might he considered today to be a 'jingoistic' atmosphere. In other words, one was taught to be fond of one's country, proud of the British Empire and to be ready to fight any foreigner who showed any signs of wanting to take them away from us. And I see no reason to change that sort of outlook – except that someone seems to have lost the Empire for us.

In 1939 I was convinced that one should become involved in one's war as soon as possible once it had started. For one thing one would otherwise, I was convinced, feel extremely embarrassed many years later when asked by the young what one did in the war. The maddening thing is that they hardly ever do ask you and now not many of them are young any more anyway.

The local recruiting sergeant and I were accustomed to having an occasional beer together while we discussed the likelihood, or other-wise, of war. The sergeant lost the bet when the balloons went up. I think it was the last thing that recruiting sergeants expected.

I naively hoped to join some military unit with horses closely and obviously attached. One of the oddest things about my war turned out to be that the first time I rode a military horse was in the African infantry and that it was my army service that eventually helped me to become a professional cartoonist late in civil life.

Unfortunately my wife did not share my views on a man becoming actively involved in a war as soon as possible, especially as I could have stayed in a reserved occupation as an editor. We had no children; for one thing she had always said she didn't want any. Nevertheless she did not think it right that I should go forth to battle and it became a bone of contention.

The recruiting sergeant thought that there might still be some horses

in the Royal Artillery and so I duly joined the Royal Artillery; the horses
had left. I officially joined the army in 1939, 'signing on' and all that.
It transpired that the Army was so anxious to have me that they did
not send for me until January, 1940. A Press photographer, whom I
had known for some years, named Len Chetwyn, had volunteered to
join at the same time and on a bitterly cold day there was an open
Army truck waiting for a group of us who had travelled by train from
London to Brookwood station near Aldershot.

We were taken to our barracks at Blackdown, standing up in the back
of the truck and judging from the outspoken comments and my own
thoughts, much of whatever patriotic and 'flag-bashing' ideas had orig-
inally inspired us had been shaken out of us by the time we were received
by a regular Army sergeant. 'You're all volunteers, aren't you?' he said,
adding, 'You silly sods!'

We had a long spell at Blackdown, learning how to march up and

Gunner Tickner standing top left; 24th Medium Heavy Training Regiment
RA, Blackdown, Hants, April 1940.

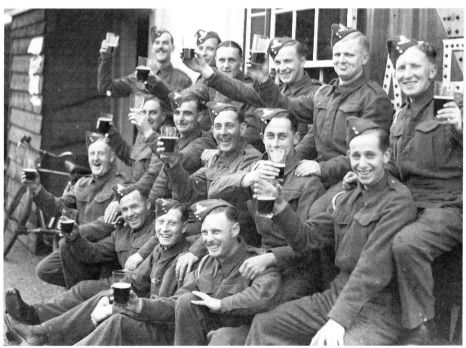

down and how to 'lay' medium-heavy guns (six inch howitzers and sixty-pounders) which we could never fire because, for one reason, there were too many civilians living in that area who would have been much annoyed and severely damaged.

We spent weeks not firing guns while winter turned to summer and we were ordered to stand-by to go to France. Meanwhile there was some sort of hold-up due to a shortage of guns to send with us and latterly explained by a story that the Army was coming away from France because of trouble at a place called Dunkirk.

After quite a time during which we sat about in the sunshine and I had an opportunity to do drawings of us doing so, which naturally enough were not for publication, a batch of us was sent off to some undisclosed destination by train. This involved a long night journey with countless stops and long waits between stations during which it gradually became evident that the War Office was trying to lose us for the duration and appeared to be doing so in a northerly direction.

From time to time rations were handed to us and one morning we awoke to find ourselves in a Yorkshire railway station. We 'fell in' outside the station which also meant outside the railway pub, the kindly landlord of which saw to it that pints of beer were passed along the ranks while kindly sergeants, whose voices and aspects had hitherto seemed most intimidating, looked the other way or joined in.

Thus began a long, dull spell in a heavy artillery regiment which was thought to have one or two immovable guns of great weight which I, for one, never saw during the few months I was with them. I and a few others, were sent to the signals section of the unit where we spent days 'flag-bashing' in an old-fashioned way.

Then one day relief came in the form of a signal asking for volunteers from all units of the Army for 'special service'. There was no indication what it meant specifically but it indicated a change from doing very little and the chance of action. A number of us applied and meanwhile received an indignant message from the old colonel in command of the unit in which we were doing almost nothing, to the effect that we were being bloody-minded and deserting him. We were, nevertheless, taken by truck some miles away from Skipton, the town near which our unit was based, to be interviewed by an officer who proved to be our future troop commander in what was the first group of Commandos,

formed from volunteers from throughout the British Army.

We returned from the interviews without having learnt whether we had been selected or not. The basic requirement, apart from the obvious ones of having been trained as some sort of soldier, appeared to be particular physical fitness, an ability to swim and a willingness to 'have a go' at the enemy. The rest depended on the general impression one had made on the interviewing officer. We waited anxiously back at the unit until summoned to Scarborough.

On the platform at this pleasant seaside town to receive the small and somewhat motley group we constituted, were our troop commander who was a Major Ferguson, two junior officers and some senior NCOs. This was the start of Number Six Commando and we hoped, some swash-buckling adventures lay ahead at last. My brother Michael, in the Merchant Service, was already a prisoner of war, his ship having been sunk by a German raider.

Men constituting each troop were told to find their own billets in private houses in the town, shown where to rendezvous in Scarborough next morning – outside the swimming pool to begin with – and dismissed.

We found a billet, two of us sharing, with some pleasant householders, settled in and went off to a pub to discuss prospects. We had been given a brief idea of what the Commandos (an idea of Winston Churchill and Roger Keyes, we understood) were expected to do; we were to make raids on coastal positions in enemy-occupied territory; all very hush-hush, cloak and dagger, dashing and romantic, we felt. Little did I, or probably anyone else, suspect it but what lay ahead were months of frustration, a lot of amusement and, most interesting of all, to me, the opportunity for much cartooning.

The reason for meeting at Scarborough swimming-pool was obvious as soon as we paraded there; it was for the first of the tests we were to undergo to find out whether we had the qualifications we had claimed at the initial interview, in this case, whether we could swim.

The officers and the sergeants stood on the side of the pool and the rest of us lined up in swimming trunks and, on a command, jumped in and proceeded to swim across or attempt to do so. One or two splashed violently about and then sank. As they did so in fairly shallow water the only damage was to their pride. They were returned to the army

unit from which they originally came within the next few days; although they were officially told that it was no disgrace, 'RTU' meaning 'returned to unit' was felt to be a reason for shame and it must have been extremely embarrassing for the men when they arrived back in their battalions.

It became obvious to me from the first few weeks, that there was going to be plenty of material for cartoons – the swimming tests alone had proved that – and later training, including forced marches at night, cliff-climbing and above all, exercises in landing from small craft in the dark, made hilarious subjects, the cartoons of which seemed to go down well with the troops.

We soon moved from Scarborough and spent a short spell on the south coast when the German invasion alarm began. We arrived at Littlestone in Kent just before the Battle of Britain for which we had

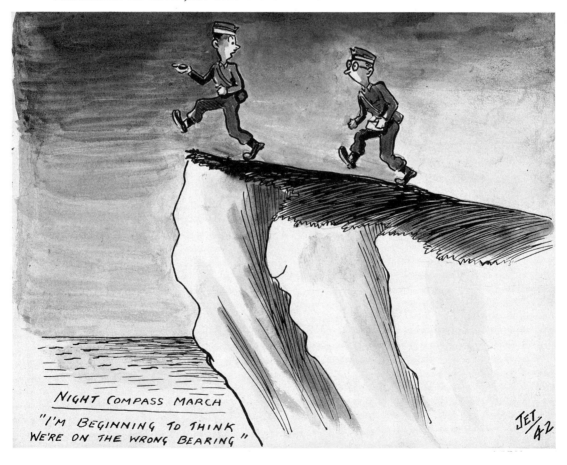

NIGHT COMPASS MARCH

"I'M BEGINNING TO THINK WE'RE ON THE WRONG BEARING"

front seats. Falling planes, our own and the enemy's, became familiar sights as did the hordes of enemy bombers going towards London.

Occasionally we were the object of attacks by lone planes and once or twice we were machine-gunned. There was an incident when a German, crossing the coast homewards, spotted a group of us on rough ground near the beach and dive-bombed us, the near-miss covering us with soil. There was a Spitfire close behind him and as he rose from his dive there was a rattle of machine-gun fire. The German plane caught fire and we saw the pilot bale out and his parachute open. As he began to float down a whisp of smoke appeared at the parachute's edge. It burst into flame and withered and the pilot's body, turning head over heels as it fell, disappeared behind the sea wall.

Later, after a short time on the Essex coast, we began training in the Scottish Highlands and from Greenock and Gourock, using more convincing-looking landing-craft and operating from special ships including converted Belgian ferry vessels.

These produced a cartoonist's delight. We worked, of course, in co-operation with the Royal Navy – a collection of extremely jolly chaps who apparently thought it was enormous fun when the 'brown jobs', as they rudely called the Army, got extremely wet; I found it difficult to believe that their navigation was so faulty that they really accidentally ran the landing-craft aground on a small rock out in deep water 'mistaking it' for the shore. It was certainly an example of seeing things from both sides as I was usually one of those who had to rush out enthusiastically into the dark, wet unknown.

Another great source of fun was the use of scrambling nets, ropes arranged like giant tennis nets, flung over the side of a ship, down which troops clambered, in pitch darkness, into small boats or landing-craft many feet below. Really clever or cunning characters, of whom we had many in our ranks, soon learned to travel down the ship's sides standing on the heads of the men who had gone before and were immediately below. In those days we all wore steel helmets.

From time-to-time we had secret orders to parade on certain quaysides on dark nights and go silently aboard. We then slipped out to sea convinced – convictions supported by rumours – that we were about to raid an enemy coast. Usually we sailed about, goodness knows where, sometimes dropping a few depth charges and always practising getting

into landing-craft and, just when we were really keyed up, sailing, frustrated and embarrassed, back home again; we had either been on yet another 'exercise' or it had been intended to be a genuine raid which somehow the enemy had found out about before we had.

I had transferred to the Intelligence section of the Commando, the Intelligence Officer being a likeable Frenchman, who called himself Paul Loraine, which we gathered was not his real name. We were due to go on raids with the rest of the troops and were sharing their frustration while waiting for action.

I had now begun to buy supplies of paper, drawing pens and bottles of Indian ink which I carried about with me throughout the rest of the war.

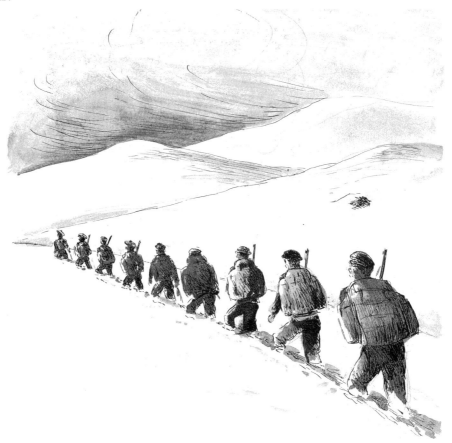

THE LIGHTER AND DARKER SIDES OF WAR
Training in Scotland in the Commandos

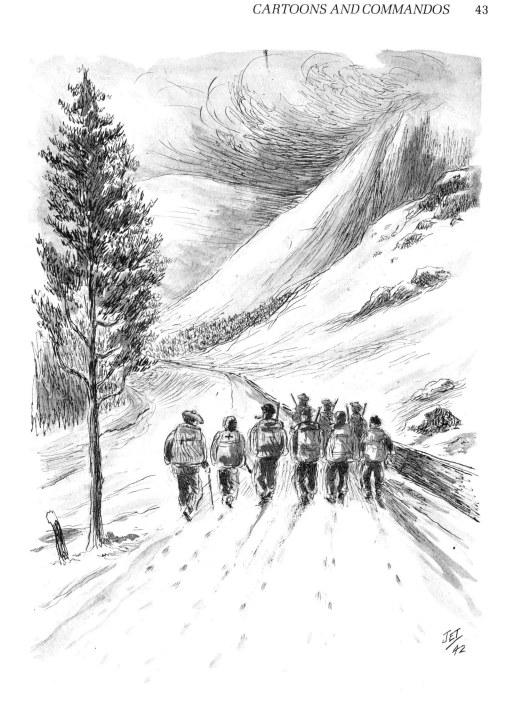

The road to Luib, 29 January 1942.

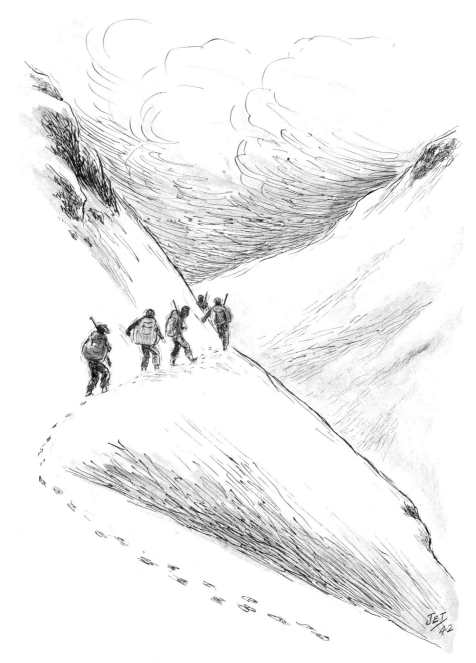

Crossing the pass to Balquhidder, 30 January 1942.

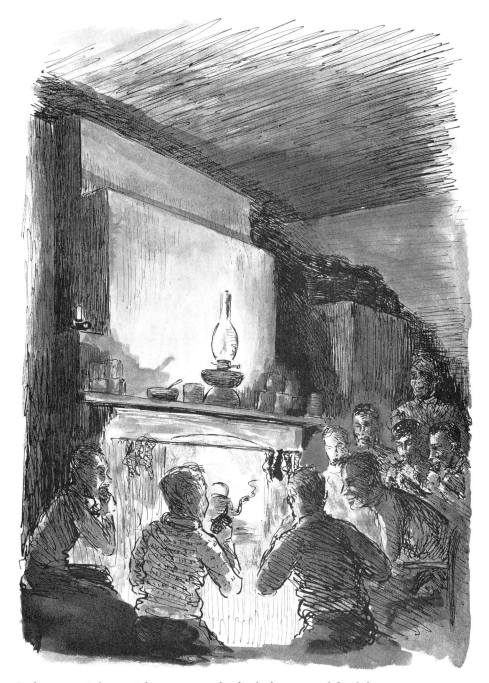

In the trapper's hut, 3 February 1942, the day before my 29th birthday.

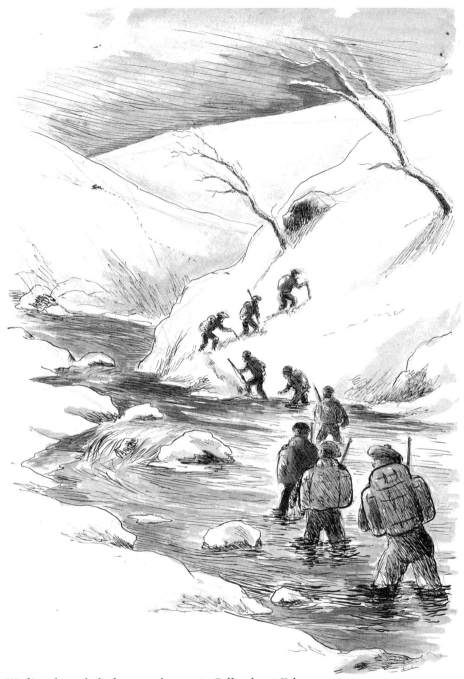

Wading through the burn on the way to Callendar, 3 February 1942.

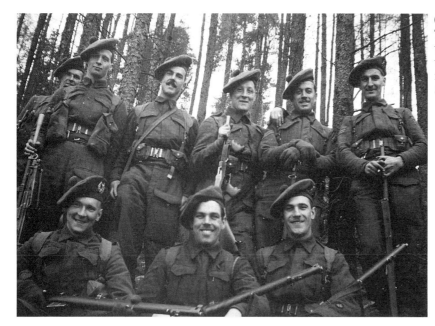

Gunner John Tickner (standing third from left), with 6 Commando, training in Scotland, 1941

At last there came the real thing, well almost. We had assembled on the usual Commando ships at Scapa Flow, going aboard on a dark night in order to be as unnoticeable as possible. As usual and quite reasonably, we in the ranks had no idea of our destination or when we were sailing or why, but we were put to work at once, preparing for action.

We were soon aware that the Press was accompanying us. Two film photographers appeared and began to film a group of men who were priming hand-grenades – in other words converting them from harmless objects into live bombs; they would explode almost as soon as the pins were pulled. The grenades were being placed in two groups on one of the mess tables below decks, one group of 'lives' and the other of grenades waiting to be primed. The pins had to be pulled out of the latter before they could be primed.

The rest of us were encouraged by the photographers to crowd round to make the most interesting picture possible for use as a news-propaganda film. Suddenly there was a hissing noise, someone shouted 'get down!' There was a scramble and I was among those knocked flat on their faces and buried under a heap of men.

There was a flash, a violent explosion and then silence. When the smoke and dust had cleared, a nasty mess was left and the cliché 'there

was blood all over the place' was appropriate. People were pulling themselves and each other together as fast and as calmly as possible. An officer standing near me said 'Oh, Tickner, clean up that mess will you!' I and several others, finding that we were still whole, collected some buckets and set about the unpleasant job of mopping up the untidiness.

What had happened was that, in the excitement of the filming, there had been some mix-up with the piles of primed and unprimed grenades. There had been a few dead and wounded, a most unfortunate beginning to a raid. In addition, the sea had become very rough. It was decided, however, that the raid must go on.

Before we sailed, some of us had watched a midget submarine leave Scapa Flow, presumably co-operating with us on our raid, probably preceding us on reconnaissance, a job requiring considerable courage.

Soon after we left port we were informed of our destination – it was up the Helle Fjord in Norway. The immediate job of the Intelligence section, of which I was a member, was to study a plan which had been carefully prepared on the advice of the free Norwegian forces and members of their 'underground', some of whom were accompanying us.

Our French Intelligence Officer had a list of allegedly pro-Nazi villagers, supplied by the Norwegians. Two of us, including myself, were writing the names alongside the dwellings; it was intended that collaborators and other important characters, among them people who would be useful in Britain, should be picked up and brought back. I remember expressing surprise that one of the collaborators was a girl of sixteen. I was told to ignore that name. 'We have to consider jealous ex-boyfriends whose girls have been out with German soldiers!'

By now the sea had become extremely rough; the destroyers forming our escort frequently disappeared beneath the waves and our own ship, because of the heavy landing craft we were carrying, was rolling and pitching violently. We were sleeping in naval hammocks instead of bunks and I found mine a godsend in that sea. Men, including the crew which consisted partly of war-time volunteers, were being sick all over the place. One exception was a young commando who kept singing at the top of his voice 'I don't want to set the world on fire!' – a popular song at the time. Nor did I, but I did not feel like singing about it. In fact, I felt decidedly queasy; most of us after an hour or two would,

I think, gladly have landed anywhere, enemy-occupied or not.

It was about one o'clock in the morning and we were now officially restricted to staying below decks. Suddenly the buffeting of the wind and the waves stopped; it was apparent that we were inside a fjord. A Norwegian slipped through the blanket hanging as a black-out screen and made his way on deck and I could not resist following. It was almost pitch dark but we could just make out the silhouette of the shoreline.

'We are just passing below the German guns,' he whispered, pointing, presumably at a cliff-top. We sailed on in the darkness. I could make out what appeared to be a large rock on the starboard side. There was not a sound or a light from the shore.

I went down below again and joined my colleagues; the feeling of tension was extreme. We all knew exactly what the Intelligence section had to do, which buildings we had to visit and what resistance we might expect.

The motion of the ship changed without warning and it became obvious that we were swinging around and going about or 'getting the Hell out of it' as someone put it in Army language. We were soon out in the open sea where conditions were wilder than before. We had no explanation but it was evident that the raid was off. Morale was extremely low – we had been through all the tension of anticipation, an 'own goal' with the grenade incident, and all, it seemed, to no purpose.

The journey home was somewhat depressing although I managed to get a few sketches. The ship was badly bashed about by the rough sea and showed it when we reached port. We were given several reasons for the anticlimax to our raid. One was that the enemy had listened in to radio conversations by the Norwegian underground and were expecting us, another was that a heavily escorted convoy had unexpectedly taken shelter in the fjord from the gale and the third was that both the stories were true.

At one time during the worst of the weather conditions it was reported that a member of the Commando was missing, believed to have been swept overboard. He was quite a small man and when last seen was looking rather ill. During a last search of the ship after we had returned to Scotland he was found, unconscious through severe sickness, in a potato locker into which he had crawled.

Kilimanjaro to the Chindwin

THERE were individual and collective activities carried out by Commandos which were secret at the time and some of which must always remain so; probably more than have ever been published. Nevertheless boredom and frustration became increasingly prevalent and many officers and men of the Commandos voluntarily returned to their original units. There were even questions asked in the House as to why there were so few raids carried out. Little did they, or do they still, know what really happened.

Three of us from the Intelligence section of my Commando – a Cambridge graduate, an ex-Oxford man of half-Norwegian descent, and myself – felt that the nation now needed us as officers. Surprisingly, we had to go before a tribunal of senior military persons to persuade them that this was so.

I found myself standing, more or less to attention, in front of three distinguished looking men who each asked me what I had done in the military sense, what I was doing and what I wanted to do. One of them, obviously trying his best to look like Earl Haig and mostly succeeding, asked me what my Commando had done. 'One of our raids has been mentioned in the Press,' I said in my best clipped, officer-type manner.

He then asked what we were likely to do in the near future. I looked at them each in turn. 'As you doubtless know, gentlemen,' I said, looking as stoney-faced as I could, 'a raid on an important enemy coast position has been arranged and will take place shortly but as you are doubtless aware, we must not talk about it.' The senior military persons looked at each other knowingly, signifying that they individually knew all about it but were certain that the others did not. They could not have done; as far as I knew, we were not about to go anywhere nor raid anyone.

It seemed that my plan of campaign worked; I was recommended to be sent to an OCTU (Officer Cadet Training Unit) as soon as possible. Nobody was more astonished than I was.

The OCTU was in a former holiday camp near Morecambe in Lancashire. The accommodation was quite good and the food adequate. We shared rooms in pairs. My companion was a pleasant person, a barrister by profession who was also a sergeant-major in a territorial unit. He did not stay the course because, it was alleged, he confessed that he had once had VD. This was a ridiculous reason – he was probably the most obvious officer-material of us all.

The course itself was a mini-version of the war as experienced by most soldiers – a mixture of utter boredom, farce and fright. It was just after Dunkirk and it was said that Montgomery insisted that future training for officers should be longer than it had been. It was the longest ever course – five months. The first, and the longest part was spent in drill on what had been tennis courts, under Guards drill sergeants; I still walk upright even when I feel a good droop would be more suitable. Apart from drill which involved pretending to be platoon commanders and even battalion commanders, in turn, we had to do some of the things we had done in the Commandos, only not so well, especially in the dark, in fields studded with cow-pats and often cows.

All the time, in the evenings when I should have been studying manuals which would tell me how to be an officer, I was producing cartoons in a sketchbook. One of the Guards sergeants eventually obtained possession of this and it reached the commandant who, I was told, thought it quite amusing. At the end of the course there was the traditional concert in which talented future officers, some of whom became famous as singers, musicians and, understandably, comedians, and in a few cases as officers, performed.

It had not occurred to me that I should be involved but one of the instructors insisted and I found myself drawing cartoons on a large easel on the stage in the concert hall. This seemed to go down surprisingly well – it must be mentioned that there was a bar in the hall and that my audience, as well as I, had made use of it before the show began. Some people have said ever since that I was the only man who cartooned himself into a commission.

Those of us from the Commandos had arranged, we thought, to return

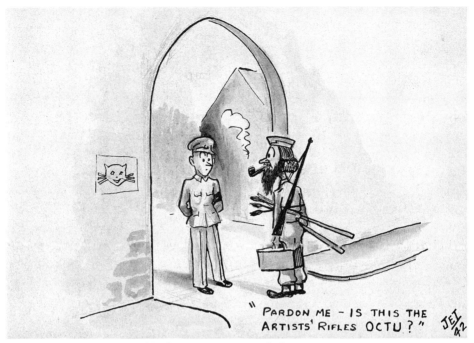

This, and the following half a dozen cartoons, with their original captions, were drawn at the OCTU at Morecombe, Lancashire.

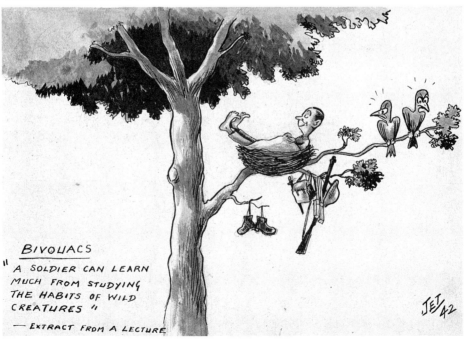

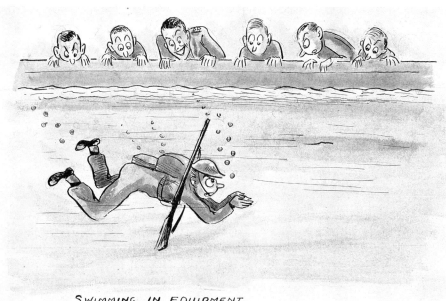

SWIMMING IN EQUIPMENT

" — AND NOW, I SUPPOSE, HE DROPS A RUDDY DEPTH CHARGE AND SHOUTS 'YOU'RE BEING FIRED ON !' "

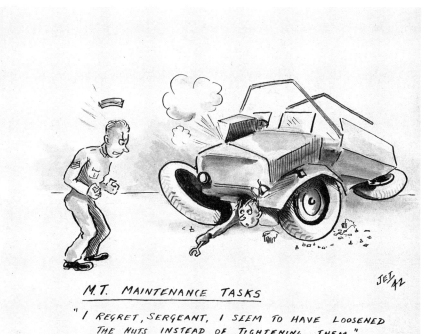

M.T. MAINTENANCE TASKS

" I REGRET, SERGEANT, I SEEM TO HAVE LOOSENED THE NUTS INSTEAD OF TIGHTENING THEM "

"A FEELING OF GROWING STRENGTH AND PHYSICAL ABILITY WILL BRING A SENSE OF SELF-CONFIDENCE"

— ARMY TRAINING MEMORANDUM No. 41
PART III · TRAINING

"PRIMROSES, DAFFODILS ETC WILL NOT BE PLACED ON KITBOXES FOR INSPECTION"

— EXTRACT FROM COMPANY DETAIL

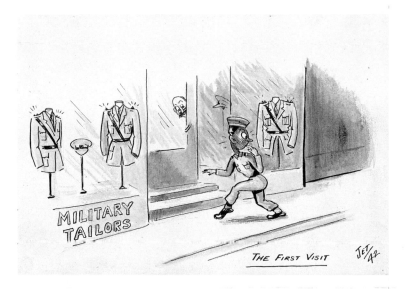

THE FIRST VISIT

to our former units as officers. We first had to join a 'proper' regiment, a Commando not being one, and I had been commissioned in the Royal Berkshire. Reporting to the adjutant of a battalion of the Berkshires stationed in Norfolk, two of us explained the situation to him. 'Sorry,' he said, 'I don't know anything about that. This unit is being disbanded and you'll be posted on somewhere else but not the Commandos so far as I know.'

Accordingly I found myself among a large group of officers assembled in a former London hotel. Nobody seemed to know why, where we were going or when. We slept at home but had to report regularly and, naturally, we frequently answered the roll call for each other in order to get a few extra days illegal leave.

Eventually we sailed on a ship of 26,000 tons, intended originally as a holiday cruise ship, for an unknown destination. Our party consisted of about fifty officers but there were many other bodies making up the ship's company.

It was crowded but there was, at that stage of the war, still an atmosphere of luxury. What originally had been the ship's rather grand first-class restaurant was the Officers' Mess and we slept in first-class cabins, in our case three in a two-berth first-class cabin. One slept on the floor, taking it in turns. I had met Maurice Bowden, a fellow officer in the Royal Berkshires, briefly when I first reported to that regiment and now

we met again. There was a bar and we spent most of the voyage chatting about civilian life and suffering no pain, although limited by a junior officer's pay.

We changed ships at Durban and after a day or two being hospitably entertained by the locals, to the extent that I almost ruined my best service jacket by getting it smeared in oil while climbing over a railway truck to get back to the ship, we sailed on to Mombasa.

From here we entrained for Nairobi and were surprised to see, from the carriage window, as we travelled into the interior, herds of antelope and zebra as shown in the big game and travel films which were becoming popular at home.

At Nairobi we spent some time in a camp on a hill beyond the Cathedral. On arrival, when the dusk, which in those parts is brief, had come, one of our party remarked on the size of the bats and another commented that if the earthworms we had seen were all of that size he dreaded to meet the snakes. Everything in Africa seemed larger than life.

On our first night in quite comfortable huts we were awakened by hysterical laughter, a noise to which one became accustomed. It has nothing to do with mirth. It is the way in which hyenas converse and quarrel, especially during meals, but it is disconcerting to humans accustomed only to the barking of dogs and the singing of cats.

That night, we were told, a leopard had stolen someone's dog from a house in Nairobi. Leopards, they said, put dogs high on their menu. We had arrived in the darkest suburbs of Africa.

Myself, when Intelligence Officer, 13th Battalion, King's African Rifles, photographed on leave in Nairobi, Kenya, 1942.

We were now, we were told, officers in the King's African Rifles. We had not long to wait before we were posted to our respective battalions and Maurice and I were able to join the same unit, the thirteenth battalion, and set out to do so, first by train and then by truck, rambling through the bush in vehicles driven by African soldiers or 'askaris'.

On arrival in a tented camp among the thorn trees at Thika and, apparently, miles from anywhere, we met the adjutant, were shown our tents, allotted our orderlies and introduced to the commanding officer, Lieutenant Colonel Humphrey French, a veteran of war in Africa already, having served against the Italians in Ethiopia. He made us feel at home at once. We were appointed platoon officers and allotted our respective units but it was not long before I was made Intelligence Officer to the battalion with a white sergeant, Freddy France, an African sergeant and a section of black askaris.

Apart from the scenery of distant forests and mountains, what I found most memorable about Africa was the African night. It was full of noise. There was the usual concert of cicadas or similar grasshopper-type insects familiar anywhere in the warmer parts of Europe and all places tropical, as well as distant barks, growls, coughs, moans and roars.

Enquiries of hardened fellow officers who had been out in Africa at least three months ahead of oneself, not only made them feel important but improved one's knowledge of local natural history. The moans and whines and, of course, the idiotic laughter, were caused by hyenas who wandered around the camp at night, while the distant roars were perhaps caused by lions or ostriches who can make somewhat similar noises. Leopards do a sort of growly, coughing noise. It was not, however, lion, leopard or ostrich country, they added and therefore one should ignore any noises that sounded like them. I found this difficult, especially the soft padding, snuffling or light skittering sounds around one's tent.

I did ignore the gnawing noises that awoke me one night. I went back to sleep and found, when I wanted my morning bath, that something had eaten it. It was made of canvas and, according to my African orderly, pointing to large quills lying around, had been regarded as simply delicious by a prowling porcupine. He added that these creatures tended to 'shoot' or discard some quills when alarmed; my snores had undoubtedly disturbed it during its meal, he said.

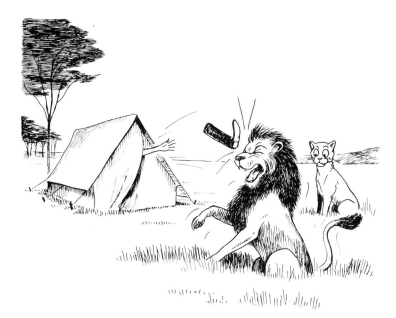

There was not always a rapport between the military and the wild life.

Training askaris (African troops) was similar to training British troops except that the Africans seemed to enjoy their time on the parade ground whereas some British troops, especially those who were only soldiers 'for the duration', like me, obviously found it boring. I disliked taking part in drill – a sense of the ridiculous prevailed, although I realised no soldier should have such a thing – and yet I enjoyed, and still do, watching experts doing it, as in the magnificent Trooping the Colour. Amateur drill is nearly always awful.

I was not sure why the CO decided to make me IO (Intelligence Officer) – could it have been because he couldn't imagine a journalist doing any other Army job or because he thought I looked intelligent or just because he knew I had served in the intelligence section of a Commando? One evening I was reading a book sent me from home. It was Evelyn Waugh's *Put Out More Flags* and in it there is a character of whom it is written 'They made him IO because he was untidy on parade'. I did not wonder any more; I became, in my own opinion, one of the smartest officers on parade but I remained IO and so I still wondered.

We moved camp from time to time and because animals always interested me, I was never bored. In addition to the assorted creatures, there was the scenery.

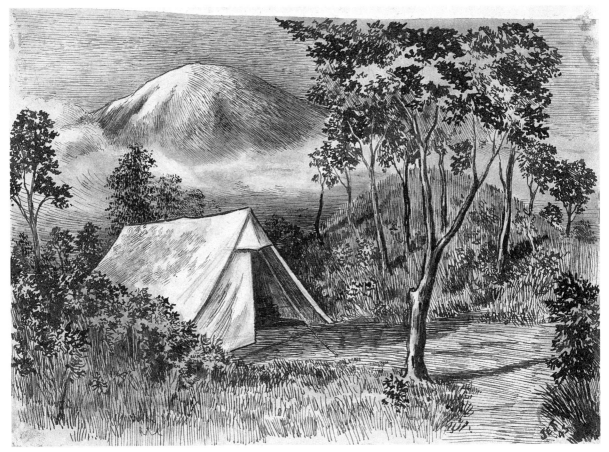

My tent below Kilimanjaro, July 1943.

When the Eleventh East African Division was gathering at Moshi in what was Tanganyika, now Tanzania, I had a perfect view of Kilimanjaro, the highest mountain in the continent. Naturally I had to sketch it. I was doing so, one hot Saturday when my friend Maurice Bowden who had a tent nearby, called in. By coincidence the officers' alcohol ration had recently arrived and so I was able to offer him some hospitality. The next day, I must record, I honoured his tent with my presence and he, too, was hospitable.

During his visit he watched me working for some time; as Saturdays were rest periods, I had a mug containing gin-and-water and another containing water for my wash-and-line sketch, standing on the rough

hand-made table run up for me by my orderly. Maurice picked up my paintwater mug, sniffed its contents, tasted them and looked at my impression of Kilimanjaro. 'That's the best gin-painted picture I've seen' he said. To muddle up the mugs was a simple mistake. Anyone could make it.

We went for route marches through the African bush, where there weren't many visible routes, and saw African villages and wildlife. Cheetah and the occasional leopard appeared suddenly from behind bushes and as rapidly disappeared. We saw herds of zebra, wildebeest and groups of giraffe.

I was disappointed that I had not yet seen a lion and so, on the advice of the local District Commissioner, with my Intelligence Sergeant, the most efficient and loyal Freddy France, pitched a tent some forty miles from camp for a weekend during which we hoped to see some of the beasts at close quarters.

In the night we heard them roaring not far away. We were, incidentally, in the country of the Masai tribe who still protected their herds from lions, using only spears.

Sergeant France and I had gone for a stroll on the last afternoon, leaving our orderlies to pack up the tent and our kit. The light was fading when we spotted the orderlies running towards us as if the Devil was in pursuit. 'The lions have arrived!' they gasped in Swahili. We hurried back to the camp site. The tent lay folded on the ground. All was quiet. 'Where,' I asked 'are your lions?'

It was now almost dark. 'There,' said one of the orderlies, a town boy by birth, pointing to a group of dark shapes. 'Don't be stupid,' I said, 'those are bushes.' 'If they're bushes, Sir,' said Freddy France, 'they're remarkably mobile. They are walking about.' And so they were, a pride of four or five of them.

Just then the truck arrived from the camp to pick us up. Not only did the lions not flee in fright. They sat around and watched us depart, without comment.

Another lion occasion was when I was acting as an umpire on a training scheme. I had just left a group of fellow-officers and walked past a thick bush. There was a murmur from the men behind me. I turned round in time to see a lion bounding away from the bush. The lion and I had been within a few yards of each other. The lion looked annoyed.

We used to go to Nairobi when on leave, staying at the Officers' Club or one of the quite well-equipped hotels. A restaurant which we frequently visited was the Lobster Pot where a former white hunter held sway, white hunting being out of fashion during the war. His name was Cleland Scott and he was famous for having kept lions, more-or-less free-range, at the Lobster Pot before we arrived. He had, however, a couple of young leopards loose in the cellar, I was told, the lions having been returned to the wild.

I made a point of getting to know him and he promised to take me down to the cellar one afternoon and let me sketch the creatures. I was not particularly worried as I knew his reputation for 'having a way' with all big cats and I assumed he would stay with me. I arrived, with sketchbook, at the appropriate time. Mine host was ready for me and we duly descended to the cellar.

On a two-tier bunk bed in a corner were two leopards who gracefully and, apparently enthusiastically, came to greet us. 'This is Alexander and Alexandra,' said Cleland Scott. 'Now I'm afraid I've just got to pop out and do some shopping but I shan't be long. By the way,' he added, 'you'll have to lock yourself in, otherwise the door will swing open and they'll get loose in the restaurant which won't do at all. They don't like the smell of the African waiters and might turn nasty.'

He went on to explain that the leopards would probably fight each other 'like puppies' and would make loud and fearsome noises. It might be advisable to lean with my back against one of the pillars when sketching, he advised, as leopards tended to leap on the backs of creatures and he didn't know what they might do after they had knocked one flat on one's face. If they were 'fighting' in front of the door when I wished to leave I only had to thump them on the nose and they would desist and go away. He then went away himself.

With my back against the pillar, I produced some extremely shaky sketches while the playful leopards attached themselves to me, each of them folding front paws around one of my ankles and growling, in fun, I hoped. As soon as they allowed me to move, I went to unlock the door. The leopards immediately became a snarling, interlocked bundle against the door, presumably playing to the gallery. When I could make out one from the other, I thumped them both on the nose. They fell back in astonishment and as I pulled the door shut behind me,

there was a thump several feet high (about man high) on it.

I returned that evening with my shaky sketches. 'You didn't stay long' said the leopards' owner. 'I was only away about an hour!' He was not much impressed by my drawings, I thought.

Animals were always very much in evidence, although mostly as background noises. There was the occasion on which four of us spent a weekend looking for elephant. We had been told that a small herd emerged nightly from a forest ('forest' in Africa, I was told, 'jungle' in India and further east) which bordered a farm run by some Dutch people. They gave us permission to put a tent up one weekend near a pool which the elephants used regularly.

Nothing happened that evening but in the middle of the night my African orderly woke me to say dramatically, in his own language,

Native village, near Moshi, Tanganyika, January 1943.

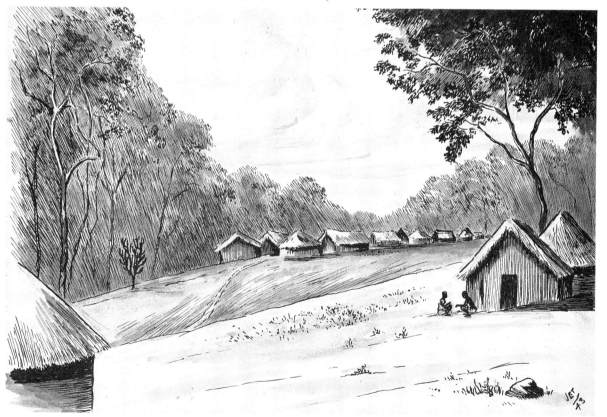

'They've arrived!' I informed my companions who were not only displeased about being awakened but were not, at that moment, interested in elephants. Feeling that it would be stupid to have gone to Africa and not encountered elephants, I went, by myself, in my pyjamas, to the edge of the forest and then, a few yards down the track in the moonlight, stopped and listened. Below me there was a considerable noise; splashing, blowing, snorting, rumbling and farting, the normal sound, I was assured later by a big-game hunter, of elephants having a communal bath. I decided it would be rude to go down and join them and went back to bed. So, I suppose, did the elephants.

It was the duty of the orderly officer, a job carried out by lieutenants on a roster, to visit all parts of the camp at some time during the night. It was an eerie experience, walking around the battalion camp which was, after all, only a large clearing in the bush, filled with tents and a few kitchens built by Africans out of branches, grasses and when possible, sheets of corrugated iron.

On one of my first nights as Orderly Officer I was approaching a company's kitchen when I heard the sound of tins being moved about, coughing and muttering. African cooks did not usually work overtime, especially in the dark, and so I moved in to investigate.

I was just going into the rough entrance when something rather smelly and shaggy came out in a blundering hurry. 'What the hell are you doing here?' I asked, decidedly startled. 'Mind your own business!' said the hyena. In the moonlight it appeared to be the size of a pony, so I did.

I was fortunate, when on leave, to find some riding stables at Nairobi and was able to have some enjoyable rides in the neighbourhood. Later, in India, we had some mules attached to the Division and I was able to get some rides on the horses that went with them, having first proved to the CO that I could ride by accompanying him on a reccy for a training exercise without falling off.

Throughout my time in Africa I was sending cartoons to the magazine, based in Nairobi, which served the Forces and was naturally particularly concerned with the King's African Rifles. Once, when on leave, I called at their offices and was asked if I would be prepared to join the staff as a resident cartoonist. I did not hear any more. I would have found

it embarrassing to have left the battalion and stayed in Nairobi, anyway.

Back in the battalion camp early one morning I found only one other person at breakfast – an almost copybook regular Army type major. He was, it seemed, 'passing through' and not enjoying non-regular type Army life on the way. He seemed to think he ought to talk to me and over the burnt toast and biting insects, inquired about my background. 'Oh,' he said, eventually, 'I think I must have been responsible for blocking an application for you to be a cartoonist on the East Africa command magazine. It wouldn't have done, you know.' He did not approve of physically fit officers in civilian-type offices.

It was decided to send all the African troops back to their villages in Nyasaland (now Malawi) on leave before going further East, one presumed, and into war. Many company and other officers accompanied

Mount Mawenzi seen from Kibo hut, which, at 16,000 feet, was the top hut on the ascent of Kilimanjaro. Bad headaches developed at this height. This was sketched at 3pm on 6 August 1943.

them but a few of us, the doctor (Paul Adler), a company commander and Freddy France and I, elected to go to the top of Mount Kilimanjaro below which we had camped for months, just for the experience.

Climbing Kilimanjaro did not involve mountaineering; it was only a long walk but demanded absolute fitness and an ability to endure heights. The summit is over 19,000 feet but there were huts at intervals in which one could spend the night and as there was no hurry, we took four days. The views, it was rumoured, were magnificent. 'You feel you can see the whole of Africa from the top,' one veteran told me. I didn't; all I saw was a cloudscape, stretching for hundreds of miles and seen from above. However, it was an interesting walk and, I understand, is now a popular tourist expedition. The last stretch, up the steep slope of loose shale, one step up and two back, with headaches and lack of energy, was the worst. Then across an ice bridge and up to the summit where there was a tin trunk containing a large book in which one entered one's name. Only two of us out of the four, feeling decidedly ill, made it – Freddy France and myself, the other two having to give up at the last stage. I have my own private records as I made sketches at various stages on the way up. Sadly, Paul Adler was killed in Burma by enemy shell fire when tending some wounded.

Soon afterwards we sailed for Sri Lanka, or Ceylon as it then was. Meanwhile I had had a short spell in hospital near our camp at Moshi, with a bad bout of malaria and was only just discharged in time.

When our troopship was near the Maldive islands, about three o'clock one very hot afternoon, the Commodore's ship, just ahead of us, was torpedoed. I remember that most of our askaris were parading below decks for a medical inspection and injection. I came up on deck in time to see the last phase of the attack. There was a gap where the Commodore's ship had been; she had been blown apart and had sunk, as the captain of our vessel remarked, faster than any he had seen. The African Regimental Sergeant Major told me he had seen it all but 'thought it was training.' That ship had on board a number of women – nurses and others – and many of their husbands who were officers in the KAR, were on our vessel and saw the disaster. One of our party who said he was on deck throughout the attack, told me he had seen a second torpedo 'bouncing' across our bows. We were told later that the destroyers accounted for the enemy submarine.

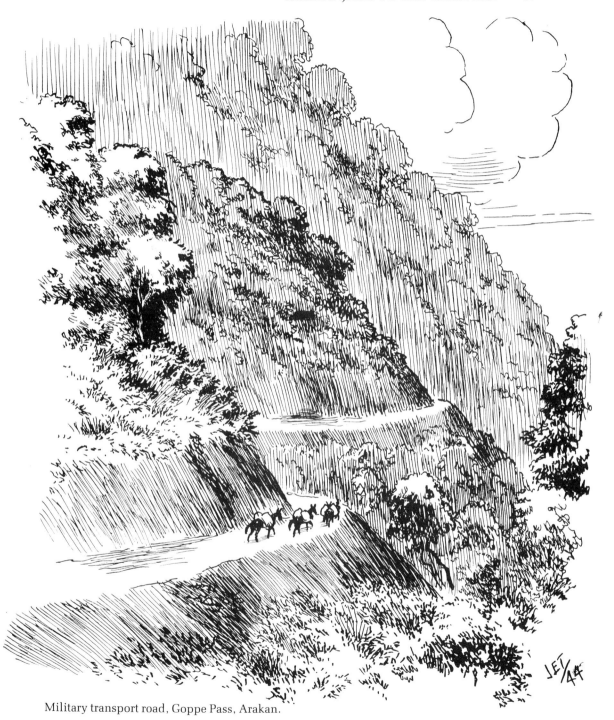

Military transport road, Goppe Pass, Arakan.

We had a pleasant time in Ceylon but after a few weeks there was a signal in code asking for volunteer officers to replace casualties in the Chui (Swahili for leopard) Scouts, a kind of mini-Chindit force operating under Colonel 'Chippy' Lewin, patrolling behind, around and among the Japanese in the Arakan region of Burma. They had experienced much action before I joined them, soon after which, our job finished, we came out of the Arakan just in time for me to rejoin my battalion before the East African Division moved into Burma through Imphal and Kohima in pursuit of the retreating Japanese after their defeat there on the border of India in a fierce battle with British troops.

This again meant patrol work for me and extremely interesting it was; long nature walks with the possibility of going quietly round the corner and meeting other people of the kind one would rather not know, doing likewise in the opposite direction.

Often, as one slept fitfully in the jungle undergrowth away from the track, it was the sound of the fauna of the region that disturbed one. Well, one hoped it was.

Once a couple of Himalayan bear cubs raced across the track and on another occasion when I had overtaken a lone Burmese villager and made him accompany my patrol (it was unwise to let them go ahead), I spotted a large pug-mark (looking like an oversize cat paw imprint) on our path which was damp and it seemed to me that the spoor was fresh. I was able to confirm with the villager that the spoor had been made by a tiger. 'How tall?' I asked, holding my hand several feet above the ground. He shook his head and held his own hand the height of a small horse. It seemed unlikely but we moved on rapidly, just in case.

One day, after a quiet period, I was instructed to cross a picturesque tributary of the Chindwin with a small patrol to find a route for a large patrol to move around a Japanese position high on a cliff at a place called Shwegyn, a small village with a temple, overlooking the Chindwin. We had not gone far when somebody started dropping shells just ahead of us. It dawned on me that I and my little patrol had been mistaken for Japanese by our side. I instructed one of my Africans to shout across the river to make the situation clear. Just at that moment small branches began to fall about my head and I realised that a Japanese machine-gunner up on the cliff was turning really nasty; he had got identification of patrols right first time. We took cover.

Night fell and I decided that it was not a good idea to move forwards or rearwards and so we settled down among the riverside rocks for the night. I had with me an Anglo-Burmese interpreter, a bank clerk from Rangoon. As the Japs said goodnight with a final machine-gun burst, he tapped me on the shoulder.

'Sir,' he said, 'this is a very dangerous place.' 'You're telling me. Of course it is, bloody dangerous!' I agreed.

'No sir,' said my townee interpreter, 'I mean this is tiger country!'

I found my way back to Brigade Headquarters and reported to a young man wearing glasses and stripped to the waist. I thought he might be the Brigade Major. 'Are you aware,' he asked in the tones of a stage regular Army Officer, 'that your presence in the middle of a battle was a considerable embarrassment?' Soon after this our battalion had a short, sharp battle with the Japs and moved them off the cliffs at Shwegyn.

We were in the Burmese jungle throughout the monsoon which I found made my sketching paper extremely soggy and life generally very damp and were then relieved by a British Division and flown out.

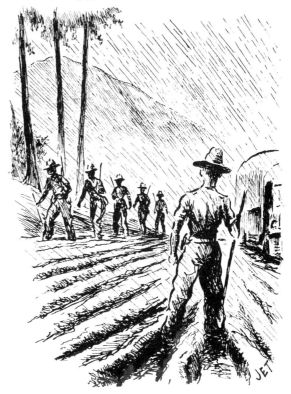

The road to Sittang during the monsoon.

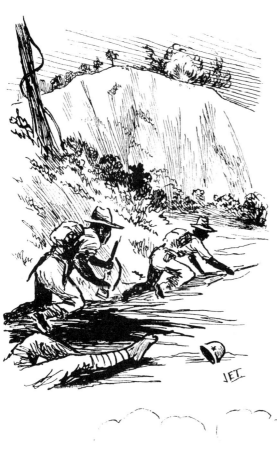

(*left*) Men of the 13th battalion KAR advancing under shell fire to attack enemy positions on a cliff at Shwegyn on the Chindwin. The Japanese were dislodged.

(*below*) The 11th East African Division crossing the Chindwin river, 1944. I made this sketch on the spot. Our shells were registering on the enemy-occupied heights.

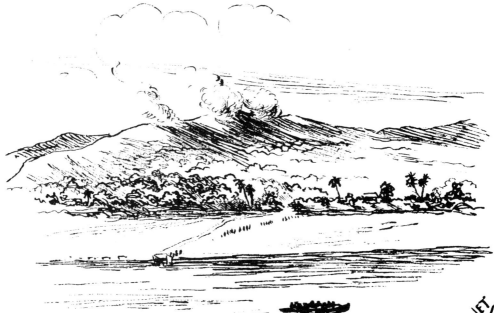

(*right*) A dead Japanese sniper.

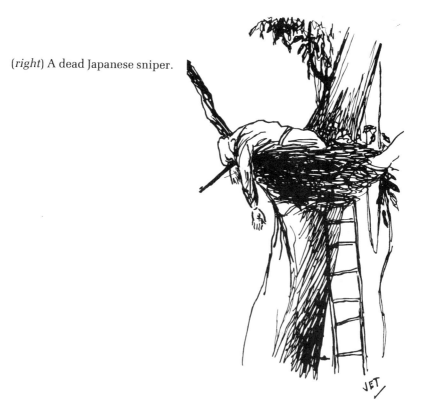

(*below*) Signs of the Japanese retreat after Imphal.

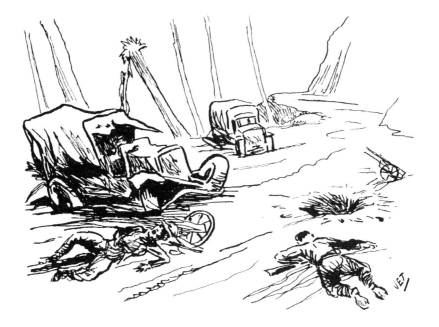

(*above*) The Chindwin River at Kongyi, near Shwegyin. Sketched from a recently-vacated Japanese machine gun position after a short sharp battle, December 1944. It was from here that the machine-gunner had paid me attention.

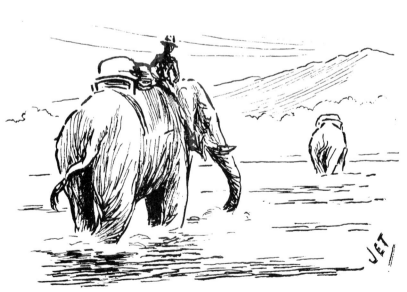

(*left*) Some of the famous Colonel Williams' elephants crossing a tributary of the Chindwin.

Back in India I spent some time travelling about on various duties in the course of which I had a ride on an elephant which placed me on its head by pushing me up with its trunk beneath my posterior so that I joined the Indian mahout on its neck, and I also acquired a young leopard which slept on my bed at night and played with a fellow officer's pet bear cub by day. I reluctantly had to leave the leopard with the bear's owner when I moved on.

The only close encounter with a snake occurred in India. Maurice Bowden and I were helping each other dispose of our drink ration one night and as he left my tent to retire to bed he exclaimed that there was a serpent in his path. I went to see, expecting a dramatically large creature. It seemed to be remarkably small but I picked up a tent-peg mallet which I threw at it and slew it, by lamplight. I feel sure that without the whisky I would not have been able to hit it.

Next day I showed the corpse to a veteran of Indian campaigns. It was, he assured me, a krait, one of the deadliest snakes in India and therefore not to be taken lightly or even with a glass of the very best whisky.

I had been able to get many rough sketches during my time in Burma, some, such as one of our troops crossing the Chindwin while our guns were firing on the Japs situated on the range of hills

Tamu Road, 1944 in the monsoon.

above and beyond them, and drawings of patrols, being carried out on the spot while others, including the sketches of air drops, were done as soon after the operation as possible.

The Division was now expecting to go to Malaya where the Japanese were still in occupation. Meanwhile I was on an Intelligence course in Assam where I stayed on afterwards to produce poster-type cartoons as illustrations for instructors' lectures and thoroughly enjoyed myself. Then The Bomb was dropped on Japan and we went home.

If I had been a person with military ambitions, demobilisation would have been unwelcome but I had, like most war-time-only soldiers, had all the military experience I wanted.

I had recently, temporarily, risen to the dizzy heights of captain and adjutant during the absence of the permanent holder of the latter post, on leave. I had also suffered the shock of being sent for because 'the Divisional Commander wanted to speak to me on the field telephone.' Generals rarely telephone junior officers and my mind boggled. It was soon unboggled; General Dimoline, it seemed, had seen some of my cartooning efforts and was flatteringly giving me an order to design the Divisional victory Christmas Card. This I duly obeyed.

11th (EAST AFRICAN) DIVISION

The Divisional Christmas Card, 1945, designed on the General's order.

THE ROAD TO PEACE AND AFTER

As they sped down the road, our men realised that any moment they might be over the Burma border.

Signals personnel overcame considerable difficulty to lay line through the jungle. Seriously, they were exceptionally brave.

Carefully thought-out plans were adopted to deceive the enemy when on patrol.

Troops were always ready to take an interest in matters connected with home.

CHAPTER FIVE

Back to Journalism

I returned from an Intelligence course in Assam to find victory cele-
brations in full swing throughout the Division. The troops had been
allowed to split up into their main tribal groups and genuine African
war dances were being performed around genuine camp fires.

The celebrations went on for several days and nights. Generous sup-
plies of alcohol, based as closely as possible on the native beer, were

On their return home, many
took some time to settle down
to civilian life.

London, 14th Army Reunion night. (Published in South East Asia Command Magazine.)

available and each tribal jollification was supervised by British officers and NCOs. We were not supposed to join in but we, too, had a certain amount of drink to hand and were feeling in party mood. It was unfortunate that I was spear-waving and leaping high in the air when I caught sight of the colonel standing just within the fire-light. I danced (gracefully, I thought) off into the Indian night; in a way it was symbolic of the end of the war and my impending demobilisation. So it seemed to me at that euphoric and alcoholic moment but next morning an order appeared on the battalion headquarters notice board stating that officers must not take part in African war dances; quite right, too, and anyway they weren't very good at it.

The return home by troopship was orderly, cheerful but boring. It was pouring with rain at Southampton where a brass band appeared from one of the dock sheds, hastily played a snatch of what someone said was 'Here the Conquering Hero Comes', amid cynical laughter, and rushed for shelter again. No civilians had been permitted to meet their men. My wife and I met in London; we spent Christmas at a hotel at Cookham and regretfully decided, as did so many couples whom the war had parted for long periods, that things were not what they used to be and never could be. A civilised divorce followed soon afterwards; fortunately no children were involved.

I was expecting to return to local newspaper life and I was about to do so when I met Bob Dobson again. His failing sight had made him unfit for military service and he had had contact during the war with the editor of a glossy magazine, long established and famous for its publication, especially in pictures, of news of the stage and of public school and university sport and polo and racing. Its original title was *The Sporting and Dramatic News* but during the war this had been changed to *Sport and Country*.

Bob, who was now on *The Times* told me that *Sport and Country* required an editorial assistant. I applied and soon found myself commuting daily from Ealing, where I had lived in my mother's house since demobilisation, to the Illustrated Newspapers' offices at the Fleet Street end of the Strand.

I also met again Bob's sister, Monica, whom I had known slightly when she was still wearing a gym tunic, as they were called in those days. I had regarded her as a great nuisance when she knocked on the

door of Bob's 'study' on pre-war evenings when he and I were dashingly having a secret light ale and imagined intellectual conversation.

Monica and I had much in common, especially an interest in horses and, as we were both single, we often met and, hiring horses from stables on the outskirts of Richmond Park, spent many pleasant hours riding together at weekends. We married at Caxton Hall, with a reception at the Farmers' Club, in 1948.

When I joined *Sport and Country*, which was in the same group as the *Illustrated London News*, the *Tatler* and the *Sphere*, I realised that this was one of the pleasant forms of journalism, although somewhat old-fashioned. It was, I thought, all the better for that, but when what had begun as a family publishers was taken over and absorbed into a conglomeration of magazines, the individuality which had, before the war, mattered so much in a newspaper or magazine, vanished and so did and so will, many more for the same reason.

Being assistant-editor of *Farm and Country*, as it had become – to indicate the change to a farming policy – I had plenty of opportunity of meeting interesting farming, field sports and equestrian personalities. These included Sir James Turner, President of the National Farmers' Union, later Lord Netherthorpe, Sir Harry Llewellyn and Pat Smythe, both famous for their show-jumping achievements, Captain Ronnie Wallace, President of the Masters of Foxhounds Association, the late Walter Case, Editor of *Horse and Hound*, and many others.

I owe much to them for the valuable information they gave me about the lighter side of their own professions and their encouragement in my work. I am particularly grateful to Colonel Sir Mike Ansell. The revival of show-jumping and its popularity is largely due to Sir Mike, as he is universally known, who, though blinded during the war, has always worked hard to promote British horsemanship and show-jumping in particular.

Monica and I, after staying temporarily in a flat in my Mother's house while we looked around for a permanent home in the country, moved to a cottage in a quiet lane at Sundridge, near Sevenoaks, in Kent, and I commuted to London daily.

I had bought a cobby black mare, with the homely name of Mary, from a neighbour who was about to leave the district and soon afterwards I acquired another cob, a mare called Emma, for Monica. Emma unfortu-

nately proved to be an incurable 'puller' and was eventually sold to a good home and replaced by a powerful black Irish half-breed mare named Ebony, nearly seventeen hands, for myself while I passed Mary on to my wife. We also acquired Mrs Busy, of hunt terrier descent.

We used to get up early in the summer mornings and go for a short ride before breakfast after which I commuted to London. In the winter, early morning rides were obviously not feasible but I had begun to hunt from time to time, at weekends, with the West Kent Foxhounds of which Auriol Gaselee was Master. I used to 'hack on' ten to twelve miles, and could only stay out half a day because I could not afford to box the mare or keep her in the manner she would have expected if she had been hunting in the Shires.

Riding Mary, our first horse, with Monica on Emma, Sundridge, Kent in about 1949.

(*above, below and right*) Some of my drawings from *Holly Leaves*, the
Christmas number of *Sport and Country*, formerly *The Illustrated Sporting
and Dramatic News*, 1947.

In the 1950s I met, in a village pub in Kent, John Pudney, the poet, author and journalist, son-in-law of Sir Alan Herbert. John lived in Chipstead, a neighbouring village to ours, and we became friends. On one occasion he asked me to accompany him in his car while he spent a day following the West Kent Foxhounds, having been commissioned to write an article about hunting – for the *News Chronicle*, I think it was – and he wanted me to explain the sport to him.

In the course of the day's expedition I commented that hunting, about which I was an enthusiast, and horses and horsemanship generally, would make splendid subjects for a light-hearted illustrated book. To my surprise he said 'Well, why don't you produce one?' and he revealed that he was a director of Putnam, the publishers. By the end of the day he had convinced me that his suggestion was serious and so I wrote a précis of the proposed book with a few cartoons as illustrations and, still hardly believing my luck, sent it to him and waited to hear his board's decision.

After a period during which I experienced moods of optimism and pessimism as I pondered the prospects of becoming an author, I received

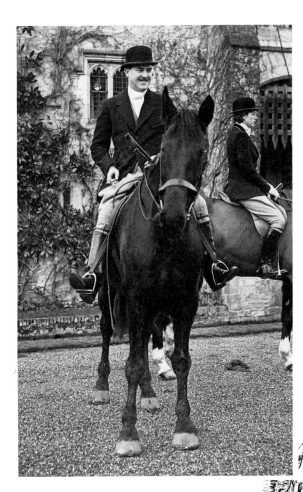

On Ebony at a meet of the West
Kent Foxhounds at Hever Castle,
Kent, in the 1950s.

Dressage in the Hunting Field. A
drawing from my first book,
Tickner's Light Horse.

the news that the idea of an illustrated book had been approved by Putnams, a contract was signed and I was told to go ahead.

I had thought of myself as a hardened and cynical journalist, but I was now experiencing the euphoria of a schoolboy who had passed an important examination.

I began writing *Tickner's Light Horse* in my Kent cottage at weekends and, during lunch intervals in London on weekdays when the weather was good, in a notebook, leaning on the parapet beside the Thames, my office being at that time, off Villiers Street near the Strand. Monica touch-typed the final copy from my dictation on tape and I did the drawings, including the dust-jacket, at home; to my delight the book appeared in the autumn of 1956.

On the day of publication I behaved (as I suspect do most authors and not only new ones) like a naive youngster; I surreptitiously peered into the windows of bookshops, prestigious or humble and even summoned up the courage to enter some grand emporiums and wander, apparently idly, around. To my astonishment and excitement, carefully concealed beneath my moustache and stiff upper lip, *Tickner's Light Horse* was among the most distinguished equestrian works displayed in the most distinguished bookshops; it was Christmas, of course, when all kinds of books are displayed.

According to my spies and relatives *Light Horse* was also seen in provincial bookshops and even the old landlord of my local inn, an ex-coachman, had seen a copy. He commented that it was 'very laughable.' I still wonder exactly what he meant.

This was an extremely happy time; the grimmer memories of the war began to fade and the lighter incidents slowly took over. I recalled such occasions as crossing an African river in a shallow dug-out canoe while huge crocodiles floated alongside within paw-shaking distance and colleagues on shore threw rocks to discourage them. Then there was a month in a former rajah's palace in India, taken over as a military hospital, in which I was a dysentery patient.

That period, apart from the unpleasantness of the illness, had a dreamlike quality; through an archway in the complex came a daily procession of ox-waggons, camels and domesticated elephants – a Kiplingesque fantasy.

But I was back in England and a reality of which I had also only

dreamed. *Light Horse* was a great success and was followed by a series of 'Tickner' books – on shooting, on ponies, on dogs, cats and rural life. Many were translated into other languages, including Dutch, German and French and they have appeared in several editions.

Putnams changed hands, their policy in the type of books altered somewhat and I had the Standfast Press as a publisher for some time before being published, as I am now, by Kenneth Kemp of The Sportsman's Press.

As Editor of *Farm and Country*, in my office in John Adam Street, London, 1963. I no longer smoke!

My contacts in London were not only horsey; through a journalist I had known for many years, Bob Pocock, I met Dylan Thomas and Louis MacNeice and spent several entertaining evenings with them in the pubs around Charlotte Street and St Martin's Lane.

Vincent Orchard, a distinguished racing correspondent, introduced me to Walter Case, Editor of *Horse and Hound*, who became a great friend. He suggested that I might illustrate the popular 'Mr Fox' stories, published in *Horse and Hound* and written by C. N. de Courcy Parry under the nom-de-plume 'Dalesman'.

This meant more to me than anyone could imagine; as a schoolboy I had saved from my pocket money to buy *Horse and Hound* whenever

possible and to contribute to it was beyond my wildest dreams. I came to know Dalesman, who lived to a good age, very well. He had been a Master of many packs of hounds throughout the country, was world-famous for his knowledge of hounds and his skill as a huntsman and was a brilliant raconteur and witty writer and his private correspondence was hilarious and mostly unprintable.

I had enjoyed rough shooting from an early age and now had Topper, a black Labrador Retriever to accompany me on rabbiting and pigeon-shooting expeditions. After we had moved across the Darenth Valley to become tenants of the late Lord Stanhope on his Chevening estate, I was able to enjoy well-organised pheasant shooting as one of his guests and, in addition, was taken by the late Dr Jeffery Harrison, who was a distinguished ornithologist and a crack shot as well as being my own doctor and a great personal friend, to the Medway marshes for dawn flights. This involved long walks across treacherous mud and waiting, often in icy conditions, for duck, returning with a feeling of achievement if one had shot anything.

Meanwhile the situation at the London office had changed considerably. We had been taken over and although I was now Editor and a company director, I decided I had had enough of London life and would prefer the hazards of a freelance existence. So, with few regrets, I left staff journalism for ever.

Wildfowling in the Mud, from *Tickner's Rough Shooting*.

(*above*) Monica with our terrier,
Mrs Busy, in the pottery at
Yetminster, Dorset, 1964. I can be
seen decorating the pottery
(*right*).

Monica's sight was failing which was making her job as a freelance agricultural journalist particularly difficult and so, when a charming old thatched cottage which had belonged to her aunt, in the village of Yetminster near Sherborne, Dorset, became available, we moved in with optimistic plans; she bravely decided to take up pottery and after a few highly encouraging lessons, suggested that we might run a commercial pottery at the cottage. This we did with partners, Bob and Eve Winders, my job being to decorate the pots.

All went well for a time. It was a most pleasant existence; we had Busy, the terrier and Topper, the now aged Labrador, with us, but we had to leave the horses behind, in good homes. However, I was able to continue a close association with horses by exercising other people's animals around the peaceful countryside. The back of a horse is a wonderful place on which to think and I thought up many future drawings and books while riding along Dorset lanes.

The wheel taking over the potter. An illustration from one of my books. The potter is fictional, but it can happen.

The trouble with the pottery, as with many small businesses, was lack of capital; the demand was there, but we could not afford sufficient staff to cope and sadly we had to close. The problem was what to do next. Our money had gone on the pottery. Help arrived from Mrs J. M. ('Kit') Fraser, of Westhide, Hereford. Her late husband, Peter, had been a great friend of mine and had contributed regular articles on farming and gundogs to the magazine I had been editing. She very kindly suggested that we should move into an empty cottage on her estate and work things out from there. Busy came too and lived to the great age of seventeen-and-a-half.

Soon after we arrived and before we could get the pottery or anything else started, Monica was taken ill and died of cancer the day before Christmas Eve, 1974.

I lived for some time on my own in a small cottage, the Lodge, at Westhide, after having been ill as a result of drinking too much and eating too little.

Barbara Gilg, the wife of Alan Gilg, who had been the Secretary and accountant to the Westhide estate since the war, in which he served in the RAF, had become great friends with Monica as I had with Alan and she had been a tremendous support to me in helping to look after her until she went into a nursing home.

Shortly after Monica's death, Alan became ill and also died of cancer. I had just previously moved into a flat in the Gilg's home, The Court, a former farmhouse on the estate, built in 1770.

Barbara and I married in 1979, continuing to live at The Court. It was an ideal spot for anyone doing my sort of work, with a perfect view from my window of woods, fields and distant hills and with horses always in the paddocks across the lane during the summer months. I had not known the lovely county of Hereford at all until Monica and I came to live at Westhide but Barbara had lived not only in the county but also in the same house for forty-five years.

Meanwhile Michael Clayton had taken over the editorship of *Horse and Hound* on the retirement of Walter Case. I had met him and was delighted when what had started as an arrangement for me to supply a few cartoons during the hunting season led to a regular weekly appearance of my work. At the time of writing, *Horse and Hound* has published over seven hundred of my cartoons.

My light-hearted books – the 'Tickner' series – were going well and this, with Barbara's strong encouragement, gave me the confidence to hold exhibitions of coloured sporting cartoons, nearly all of them hunting and shooting subjects, at various places including Hereford, the Royal Agricultural Show at Stoneleigh, Warwickshire, the Game Fair at various sites and at galleries at Cheltenham, Williton near Minehead in Somerset, and at Sherborne in Dorset.

All the exhibitions were successful and sold out and there were some amusing and salutary incidents. On one occasion at Hereford two boys from the Cathedral School came in, walked round and appeared to be examining the pictures closely. As they passed the table at which I was sitting, on their way out, one of them said to me 'Quite good!' At the same show a rather larger group of boys could be heard muttering. The voice of one rang out clearly 'Cor!' he exclaimed, 'Look at the price!' I was painfully surprised as I had thought the price, at about £20 to £25 apiece framed, extremely modest for those days. Fortunately their elders didn't complain.

At another show a man in full hunting kit called in, adding a genuine and appropriate touch of colour to the proceedings. It has been a delight to find that many people who have visited my shows have done so because they have been fans of mine through my cartoons in *Horse and Hound*. It is more than satisfying to have first-hand evidence that one is giving pleasure and making people laugh in an age when so much news is grim.

Although I no longer hunt nor shoot I still keep in touch with both, having long been an enthusiast of those sports.

Barbara and I had two young black Labradors. One day they went off into the woods together, although not usually allowed out without a human escort, and could not be found, despite much calling and anxious searching. Eventually we had a telephone call from the Hereford police who had heard from the Ledbury police that they had two, apparently stray, black Labradors. We had previously reported that ours were missing.

Our two, Seamus and Bracken, after, presumably, a hunting expedition through extensive woodland, had come out on to a main road and made friends with two children whom they had followed home. The mother sensibly took them to the police.

Two illustrations from my books (above) *Tickner's Pub* and (*below*) *Tickner's Rough Shooting*.

Over-enthusiastic polo player.

Over-enthusiastic gun dogs.

TICKNER'S BADMINTON

The cartoons on this page and on page 97 are from *Horse & Hound*.

'I know he's not the Master. He's much more important — he's judging the hunters at this year's show.'

Horse Trials: 'All these horses galloping about the place are dangerous.'

The dogs had covered seven miles, neither of them was wearing a collar and we expected a lecture from the police; instead when the dogs were released from the cell they were sharing and greeted us joyfully, the sergeant kindly and tactfully commented on their excellent condition and obvious affection for us. No reference was made to collars.

We decided to take them to the gundog classes regularly held at West-hide and conducted by Archie Hounslow, the retired gamekeeper on the estate, a jovial and most popular character, affectionately known as 'Mr H' whom I had previously assisted at his classes by throwing 'dummies' for the dogs to retrieve.

Our entry into serious gundog classes was disastrous and hilarious although I had, years before, in Kent, trained my own Labrador success-fully and used him when rough shooting.

The 'meet' on this occasion was in front of the big house, known as The Porch. Seamus, Barbara's dog, large and boisterous, found it most exciting. He made a sudden dash to talk to another dog and Barbara, who had him on a lead, went flat on her back; it was all most undignified and Bracken and I looked the other way.

Worse was to come. During the ensuing class in an adjoining paddock in which we were instructed to make our dogs walk to heel, Seamus and Bracken, being alongside each other, decided to play. This was inclined to reduce the whole class to a play school and Mr H announced that Barbara and I and our dogs were to be kept apart and put at the opposite ends of the line.

It was then Bracken's turn to make an exhibition of himself. On Mr H's instructions, I sent him out a little way in front of me. He was supposed to come back when called. He didn't; I had to climb a gate and run through a mass of daffodils, swearing heartily, to retrieve my retriever who was investigating rabbit dwellings, watched by Mr H and a group of solemn-faced members of the class, mostly females.

Seamus suddenly decided that the black labrador bitch in the care of a woman near him in the line, was most attractive and, making a sudden leap, got away from Barbara and began to demonstrate his reac-tions to her charm.

'Get him orf, get him orf!' yelled the bitch's owner (female gundog owners tend to say 'orf', I have noticed) and Barbara yelled back 'I'm trying to get him 'orf'.'

Of course, no bitch in any way in a particularly interesting condition to dogs, should be taken to events where she has to mix socially, but it can happen.

Anyway, we decided not to return to the gundog classes; we felt we would not be sadly missed, except as a cabaret turn. Meanwhile I had obtained much useful material for cartoons.

Seamus and Bracken both reached a good old age and were replaced by Lucy, a cheerful and extremely active young black Labrador who is still very much with us.

'Dog-training persons always have a tendency to talk as if they were addressing a dog across a ten-acre field.' From *Tickner's Dogs*.

Barbara, photographed in 1989 at Westhide, Hereford. We had married in 1979.

(*below*) This photograph was used in the catalogue for the International Horse Show, Olympia, 1987, for which I designed the cover.

Epilogue

Serenity

Producing ideas at any time can be difficult, but is especially so when one is going through a bad patch in one's life. One such occurred when pains in my chest were diagnosed as being caused by angina and after tests, an operation for the replacement of a valve was decided upon. I was given the choice of three hospitals, including Waldegrave Road Hospital in Coventry. The last named was the most conveniently near to Hereford of the three but I had my doubts about selecting it; as I had begun life near Coventry I felt it would have been ironic to end up in that district. However the hospital had a high reputation and I entered it in August 1988.

After a wait of several days in the hospital, during which I began to make notes for this book, I was informed, just before the date I had been given as that of my operation, that it would have to be postponed, the reason being that patients in the intensive care unit were not leaving as soon as had been anticipated, this meaning, presumably, that they were taking a little longer to recover than expected; I hoped that was the reason. Incidentally, there had been an incredibly long unexplained wait in the reception hall before I even saw a ward.

So I went home for a month, came back and was operated upon. The surgeon had done a grand job, it seems, and I was duly grateful, especially as I was told I was rather old for such an operation. What I did think to be unfortunate and unexpected was that they found I was having breathing difficulties after the operation and that a tracheotomy was necessary. Apparently I amused the young nurses by complaining that, although I thought some people may have wanted to cut my throat at times, particularly when I was an editor, I had not expected to have it done in hospital and apparently to save my life . . .

However they did it well and I was soon on the way to recovery.

Meanwhile I had ensured that my cartoons should not disappear from public view by posting off some to *Horse and Hound* in advance and continuing to produce more as soon as possible after returning home; I managed that in a matter of weeks from the time of the operation.

One is often asked how one gets ideas for cartoons and the answer is that they can come suddenly and surprisingly, while walking with the dog, having a drink in a country pub or even the middle of the night. The last is often inconvenient and the idea can have flown by dawn.

There are also occasions when things happen to oneself which might be thought to be of note to many others as dramatic or hilarious and turn out to be utterly forgettable.

I recall one hunting incident when, moving off to the first draw after a meet at Hever Castle, a girl riding in front of me let a gate swing loose on to me before I could catch it. The ground in front of the gate

sloped steeply from it and my mare, Ebony, was caught hanging across it. A distinguished and immaculately attired man behind me came to my rescue and helped to extricate Ebony after I slid off over her neck.

Long afterwards I was present at a party in London at an exhibition of paintings by ornithological artists. Jeffery Harrison, my doctor and wildfowling companion, was present and I was recounting this incident to him when I spotted the distinguished person who had come to my rescue, across the room.

Jeffery explained that he was a prominent medical specialist and urged me to re-introduce myself and recall the occasion. This I did. The distinguished specialist said yes, he recalled the Hever meet but, added, pleasantly enough, he had no recollection whatever of having seen me before. I felt rather stupid and this brought home to me that what seems a dramatic experience to those mostly involved can mean nothing to others. It is, however, all grist to a cartoonist's mill.

It is not always advisable or fair to use incidents witnessed. There was the occasion when a well-known local woman gundog trainer stripped to her undies to rescue a dog which appeared to be drowning. Thanks to her efforts it didn't nor did I ever use the gallant act as a cartoon. There are limits.

In addition to *Horse and Hound* cartoons and my books, I have been doing other interesting work such as designs for the covers of the International Show-jumping programmes at Olympia for several years, Christmas cards for organisations associated with horses and a number of other special assignments. At the suggestion of Captain Ronnie Wallace of the Masters of Foxhounds Association I contributed to the decorative drawings on the menu of the centenary dinner of the association.

I never know when I may be asked to provide some cartoons for some most important person's special occasion and I have been informed that my work is in the homes of some very distinguished dog and horse enthusiasts with a sense of humour. That is very gratifying but so it is to know that young members of the Pony Club find my efforts amusing. I now meet elderly people who say they first enjoyed my work when they had their first pony!

I often receive letters of appreciation from people in many branches of the horse world. I do not go about much in public these days. Come to think of it, I never did, except when I, most reluctantly, had to do

A commission drawn for Pet Plan.

Christmas Card for Riding for the Disabled, 1988.

so as one of the editors and directors of the previously-mentioned maga-
zine in the Thomson group of publications; taking the chair at meetings
and presiding over lunches and dinners. I have been, most flatteringly,
asked to speak at hunt social affairs but have always declined and prob-
ably regarded by the people inviting me as just playing 'hard to get';
not many would believe that an old person like myself who has knocked
about a bit and been knocked about a bit, would be shy, but I am, I
emphasise, a 'loner.'

When I was young I regarded a Master of Hounds as being next to
God. Since I have known top personalities in many sections of the horse
world I have realised how very human they all are, including Masters
of Hounds. I still recall, with wonder, the horseback collision I had
with my local MFH years ago; it was my fault but he was the first to
apologise. No-one and nothing was hurt, except a little pride.

It is not easy to believe that one's drawings and writings are enjoyed
world-wide but it was gratifying to have, not long ago, a flattering tele-
phone call from an MFH in New Zealand, made at a most tactfully conve-

At work.

nient time of the day for myself, by the way. I am also told that my work goes down well among American horse people and in many parts of Europe.

Since writing these memoirs we have bought a little house in a nearby village where life looks likely to continue as happily as ever and there is again a peaceful view across fields and woods from the room in which I work.

So long as I can keep people amused and Barbara and myself and Lucy, the Labrador, in reasonable comfort, we shall all be serene.

Other Books by John Tickner

English editions published by Putnam (The Bodley Head), the Standfast Press and The Sportsman's Press.

Index